"Sarah Beach challenges screenwriters to enter the mindset of the graphic novelist as she explores the process of turning a transmedia story into a graphic novel from start to finish. I would highly recommend this practical, step-by-step guide to any screenwriter who wishes to utilize the visual impact and pop cultural cachet of graphic novels to up their pitching game."

> — Nicole Chapman, Full Sail University faculty and
> *StayForTheCredits.net* associate producer

"In *Creating Graphic Novels*, Sarah Beach introduces screenwriters to the world of graphic novels, outlining the important differences between screenwriting and graphic novel script writing and why graphic novels are an important part of getting a story to spread. I came to this book knowing that I love the graphic novel format of storytelling. What I loved about this book is the context the author starts from on why a screenwriter would want to adapt their story into a graphic novel. The author starts from the context of building an audience around your story through a graphic novel representation and using this platform to show that your story has the power to engage an audience. The format of the book lends well to teaching the reader about graphic novel creation with the frequent interruptions by a graphical character called 'Professor Exposition.' Reading the book, a screenwriter will learn how to adapt a story for a graphic novel, as well as learn about the graphic novel industry. It's a fun book and very helpful."

> — Tom Farr, *Tom Farr Reviews*

"Sarah Beach has collected her experience and research into producing *Creating Graphic Novels* as THE textbook for anyone seeking to make a career in the business of graphic novels.

Creating Graphic Novels goes well beyond 'How To' — it covers how to start, how to work, and how to finish so you can continue to move forward. Your copy of this book should be dog-eared, marked on, highlighted and sporting a worn spine. If your copy of this book isn't well worn and well read, then you haven't done your work."

> — Beau Smith, Director of Marketing, The Library Of
> American Comics; writer/director of *Wynonna Earp*,
> *Cobb*, *Lost & Found*

"You don't have to be a graphic novelist to appreciate this book. If you are, it's a fantastic introduction to the artistic and practical nuances of the medium. If you're not, it's a terrific lesson in creative and economic storytelling, whether your stories live on film, television, or the pages of a novel."

> — Chad Gervich, writer/producer of *Cupcake Wars*, *After
> Lately*, *Wipeout*; author of *How To Manage Your Agent*
> and *Small Screen, Big Picture*

"Sarah Beach's *Creating Graphic Novels* is a thorough and welcome primer for novice and pro alike — particularly for screenwriters who've spent years adapting comics to screenplays, and have begun to wonder if their lives wouldn't be better had they simply created a comic of their own. Not that I know anybody like that."

> — Bill Marsilii, screenwriter, *Deja Vu*

CREATING

GRAPHIC NOVELS

Adapting and Marketing Stories for a Multimillion-Dollar Industry

SARAH BEACH

MICHAEL WIESE PRODUCTIONS

Published by Michael Wiese Productions
12400 Ventura Blvd. #1111
Studio City, CA 91604
(818) 379-8799, (818) 986-3408 (FAX)
mw@mwp.com
www.mwp.com

Cover design by Johnny Ink. www.johnnyink.com
Copyedited by Matt Barber
Interior design by Sarah Beach and William Morosi
Printed by McNaughton & Gunn

Manufactured in the United States of America

Library of Congress Cataloging-in-Publication Data
Beach, Sarah, author.
 Creating Graphic Novels : Adapting and Marketing Stories For a Multimillion-Dollar Industry /
Sarah Beach.
 pages cm
 ISBN 978-1-61593-194-1
1. Graphic Novels--Marketing. 2. Graphic Novels--Publishing. 3. Graphic Novels--Authorship. 4.
Comic books, strips, etc.--Marketing. 5. Comic books, strips, etc.--Publishing. 6. Comic books, strips,
etc.--Authorship. I. Title.
 PN6714.B38 2014
 741.5'9--dc23
 2014001700

Printed on Recycled Stock

CONTENTS

INTRODUCTION

A lot of factors prompted me to write this book. First off, I happen to love the comic book medium just for itself.

Secondly, graphic novels are a growing corner of the storytelling arena. The combination of words and images has a seeming simplicity that many readers can quickly grasp. The medium appeals also as a supplementary means of getting the story in front of a broader audience. As a result, more and more writers are turning to the graphic novel form as a way of building or increasing their audiences. In particular, screenwriters are hoping to use the graphic novel as an additional way of communicating their stories to those who are in a position to buy their screenplays.

To explain the growing connection between screenplays and graphic novels, consider this: there was a time when screenplays, no matter the nature of the piece, stood on their own feet. Sometimes a work might be an adaptation of a book or graphic novel, and those were often works that were far from "mainstream" in subject matter. But more and more, as

money has gotten tighter and tighter, producers both in and out of the studios have been greeting writers, whose scripts they have found moderately interesting, with the question, "Is there a book I can see?" Initially, whether it was prose or a graphic work didn't matter; it was the pre-existence of a set text that reassured them the script was not a fluke. For there are two things happening behind that question: they do want to know what the not-mainstream film might look like, in a sort of pre-production visualization; but they also want to know if the story has an audience.

FOR A "REAL-LIFE" EXAMPLE OF THIS, HERE'S THE ACCOUNT OF WRITER/DIRECTOR MARCUS PERRY:

Hollywood has its own peculiar set of rules, and for most of us in and outside the tinsel lines, they have a tendency to frustrate and confound. It's an internal system of checks and balances, decided by committee and organized in hushed boardrooms of people with degrees far more impressive than my BFA in cinema production. And however strange and alien they may seem when applied to actually making films, those of us who brave the trenches of the movie business in hopes of having our work grace a screen either big or small are subject to them. But for those who make genre films their home, over the past few years those rules have radically changed.

THE FIRST TIME I BECAME AWARE OF THE NECESSITY FOR A "**BUILT IN FAN BASE**,"

I WAS SITTING ACROSS FROM AN INCREDIBLY WELL PUT TOGETHER STUDIO EXECUTIVE DURING MY COUCH AND WATER TOUR

— a term I use for general meet-and-greets that spring up when you're circulating a new project — for a short film that I wrote and directed called *Razor Sharp*. (Here comes the shameless plug.) The short follows the adventures of a quirky corporate thief named Veronica Sharpe in a near-future America ruled by insidious corporations. However, business turns anything but usual when the data archive she's hired to steal turns out to be an eleven-year-old orphan girl named Isis who is harboring a deadly secret. Made on a shoestring budget and a heap of favors that I amassed working as a screenwriter, *Razor Sharp* came loaded with special FX, stunts, and even a few laughs. In addition to performing respectably on the festival circuit, the short also helped launch its star, Cassidy Freeman, to Smallville *fame*, so all of us involved were pleased with the response.

The film was always designed to work as a proof of concept for a feature-length version, and with that script written during post production on the short, I began to pound the pavement in hopes of taking the next step.

So cue the meeting, and cue this executive poring over the exhaustive amount of concept artwork I'd

already commissioned for the feature, in addition to the half-hour short she'd seen. After reading the script and soaking in the visuals, she looked up at me with a sort of wistful expression and said, "You know, it's really cool. But I just wish this thing was a comic book, then I'd really know what the movie is supposed to look like."

I was stunned. Had she not seen what I'd brought her? Shiny pictures of costumes and sets and nifty props! Not to mention the film I'd already shot. What was the movie supposed to look like? I made it so you'd know — that's what it's supposed to look like! It was an infuriating moment, frustrating, and a whole mess of other expletives. But the really disheartening part was: this wasn't the last time I'd hear the same response. Although initially I was completely thrown by her reaction, the more I thought about it and decoded it, the more it began to make sense.

What this executive, and many others as my general meetings unfolded, was trying to say wasn't that a comic book version of Razor Sharp would tell her how the movie was meant to look visually. It would communicate how big of a film we would be able to make, based primarily on what type of fan base the project already had in place.

The fact of the matter is, for good or for bad, Hollywood has never been more corporate when it comes to mainstream, big-budget, FX-heavy genre cinema than it is today. The studios know these types of tent-pole projects make up the brunt of their summer release slates, which in turn accounts for the largest percentage of their annual gross. So if you plan to kick around in that coveted sandbox, you're expected to come with major incentive.

Which is why comic books have never been more vital.

The reasons for the trend of mining comic properties in search of the gem that will become the next billion-dollar box office grosser are actually pretty straightforward: as film production costs continue to skyrocket, paper and ink are still comparatively cheap; an inexpensive way to realize an idea. Plus, studio logic dictates that the same crowd that frequents sci-fi or fantasy themed flicks would likely snatch up an issue or two of the same story off of a shelf, so why not take it for a test drive in the comics medium and see if it picks up any fans first? It is a way to hedge

bets — even if ever so slightly — when it comes to the single scariest term in Hollywood vernacular: the "original idea." Fortunately, I had already lucked into comics by the time my meetings were in full swing, so making this transition wasn't entirely Herculean.

There will be more from Marcus Perry in Chapter 7, about building that audience in the comic book world.

So, the hot thing now in Hollywood is for screenwriters to turn their scripts into graphic novels. It should be easy, shouldn't it? After all, a script is a script, isn't it? Then, just find some up-and-coming artist, possibly right out of art school, pay them to whip out the pages and everything's good to go!

I've had my feet in both the screenwriting and comic scripting worlds for several years. As with Hollywood, breaking into comic books (especially if one wants to write the already established characters of the major companies), takes time. And like Hollywood, you need to learn the business, at least a little. This is true, even when you just want to do a one-shot graphic novel. Which brings me to the third thing that inspired this book.

A while ago, a good friend, who had just finished shooting his independent horror/suspense film, decided that he wanted to adapt it as a graphic novel to help with marketing and possibly securing distribution of his film. I asked him what his plan was. He said he was going to find a comic artist, preferably one new and inexpensive, give the artist the screenplay and a bunch of screencaps from the film, and let him go at it. I had a strong temptation to go pound my head against a pillar somewhere. There was so much that was unworkable about that plan, I wasn't sure where to begin. The most unfortunate thing about this "plan" was that it exposed a complete lack of awareness about the process of producing a graphic novel.

It was at that point that the idea for *Creating Graphic Novels* began to take shape. Yes, there are certain skills from screenwriting in particular that will translate into scripting graphic novels. For instance, if you have managed to master storytelling structure for a screenplay, you should be able to put that skill into writing for a graphic novel. But, unlike film and television, which are so close in means of production that mastery of one medium translates easily to the other, the graphic novel is very much a different medium.

The need for a script in order to produce the story, and the fact that it needs to be visually oriented, those two points are just about the only ones of similarity. For storytellers coming from other forms of writing, there was a greater need to explain what happens in shaping the script for a graphic novel than the current few books on comic book scripting provide.

Creating Graphic Novels is designed to introduce writers to the craft of scripting graphic novels, and then introducing that writer into the comic book world — the means of production, the publishers, and the audience. For when it comes to graphic novels, knowing the audience and connecting with them is of primary importance. And the burden of doing that work often lies on the shoulders of the writer.

Successfully getting your story adapted as a graphic novel is no guarantee that a studio will pick up the property, of course. For screenwriters, the reward is that if you love your story enough to do the additional work of getting it into graphic novel form, and you get it before an audience (no matter how small), you have the satisfaction of seeing it live as it was supposed to. It won't sit locked in a drawer or cupboard, never seen or appreciated by anyone other than your close circle. For writers who have produced their story in another format, such as a novel or short story, a graphic novel expands your audience yet again, reaching those who might not care to start with a prose work. And the nice thing about readers is that once they find a writer whose work they like, they will follow that writer. They pay attention. If you cultivate your audience, you will have a guaranteed base for any word of mouth that you want to put out about a future project.

This book is not about the basics of story structure, nor about how to draw a graphic novel. It does not contain a full-blown history of the comic book medium. It *is* for writers, to introduce them to the special processes of sequential graphic storytelling. It will help writers of any sort add the graphic novel arena to their territory. Along the way, established professionals in the comics world will offer some of their personal experience, to help screenwriters new to the comics field understand what they are tackling.

CHAPTER ONE
MAKE IT POP!

*I*n the heat of July, masses of people gather for the Comic-Con International. In 2011, the 42nd annual San Diego convention saw well over 120,000 registered attendees fill the city's Convention Center to capacity. Registration had been sold out months in advance. There were no admissions for sale at the door (unless it was by scalpers, illegally doing so), as attendance has a cut-off point in order to stay in compliance with the Fire Marshal's regulations.

For the duration of the Comic-Con International, the most avid consumers of Pop Culture indulge in the advance views they get of upcoming video games, movies, toys, and of course comic books (including graphic novels). They buy toys and books and t-shirts related to licensed properties they love. They stand in line for hours to get into a presentation hall that seats 6,500 people at a shot, in order to see advance trailers for films that will not be released for another 14 months (and possibly see the stars, directors, and producers of those films). Each night they will plug themselves into the Internet and talk on message boards about what they saw and heard (if they're not on Twitter during the presentation itself), and thousands more fans around the world will read and talk back. And those are just the ordinary attendees.

Comic-Con International is only the largest of the comic book conventions. Throughout the year, across the country, conventions of similar sorts occur. Some may have a specialized genre focus, some cover the whole spectrum but on a smaller scale that Comic-Con International. But they all serve to increase audience access to the product of "Popular Culture."

The comics industry is a breeding ground for material to feed Pop Culture. The reason for that is that comic book readers don't just read comic books. Stereotypes aside, comic book readers go to work at their day jobs, as doctors, lawyers, dental assistants, hotel managers, nurses, teachers, librarians, engineers. They take their work and their families seriously. They also take their play seriously. They want to be entertained, and they want good stories to entertain them. And they like to get their stories in many ways: obviously, they love the comic book pages, but they also watch movies and television, they play video and board and card games, they even read prose books. They amuse themselves with toys of their favorite characters (action figures make excellent desk toys at work). They buy merchandise that features their favorite characters. In short, they spend money.

According to *ICv2*, which covers popular culture from the business and marketing side, Pop Culture represents a $10-billion segment of the annual economy of the U.S. alone. What is it that drives this sort of energy?

FOR INSTANCE...

STAR WARS IS AN INDUSTRY UNTO ITSELF.

There are the feature movies as well as some specials and animated series, but there are also many novels based in the *Star Wars* universe; there are video games (multiple games); and of course, a seemingly never-ending stream of toys and other licensed products.

In recent years, the flow of a story from one form to another has grown. "Stories" that originated in video games have been transformed into feature films. Some of those have led to comic books based on them. Novels, of course, have long been subject to adaptation to other media. The flow can also go in the other direction, from comic book to film to game. Each year a new variation of cross-influence appears. In 2008, a highlight of the comic book industry was the publication of a volume of graphic short stories inspired by the songs of Tori Amos. The works in the volume were not the stories *of* the songs, but the result of each creator's response to the singer's work.

IT WON'T BE SURPRISING IF SOME OF THESE STORIES GET TURNED INTO FILMS.

The Pop Culture manifested at the Comic-Con International exemplifies the type of impact any story-teller wants to have on the audience, the ability to inspire that expansive creative response, something that fires the imagination.

> SO HOW DOES ONE GET THERE?

> IS IT AS SIMPLE AS MAKING A GRAPHIC NOVEL OUT OF YOUR STORY?

> ADAPTING A SCREENPLAY, SHORT STORY, OR NOVEL AS A GRAPHIC NOVEL IS ONE WAY.

> IT IS ONLY ONE STEP IN THE PROCESS.

> THERE ARE ALSO ASPECTS OF PROFESSIONAL NETWORKING AND AUDIENCE BUILDING.

Do you want to get in on this adventure? A lot of people do. At Comic-Con International, panels and presentations about writing are frequently filled to capacity, whether it is about comic book writing, screenplay writing, or just plain *writing*. In July 2009, the Writers Guild sponsored a panel discussion on graphic novel writing that was standing room only.

There are difficulties in the process of invading the Pop Culture world this way, as it is not just about getting the graphic novel into print. The writer has to look beyond the computer screen and realize that he or she has to become part of building the audience for the work in a personal way.

Few writers are practiced in thinking about directly building and interacting with the audience. How do you do it? This is what *Creating Graphic Novels* is all about. This book is about introducing interested writers to the craft of comic scripting, as well as the processes of publication and audience building. Adding the comics arena to your skills as a writer can broaden your access to the world, and increase the potential audience for your stories.

That is what can happen when a writer plugs into the pop culture stream, and the world of comic books and graphic novels is the most active meeting ground for that encounter.

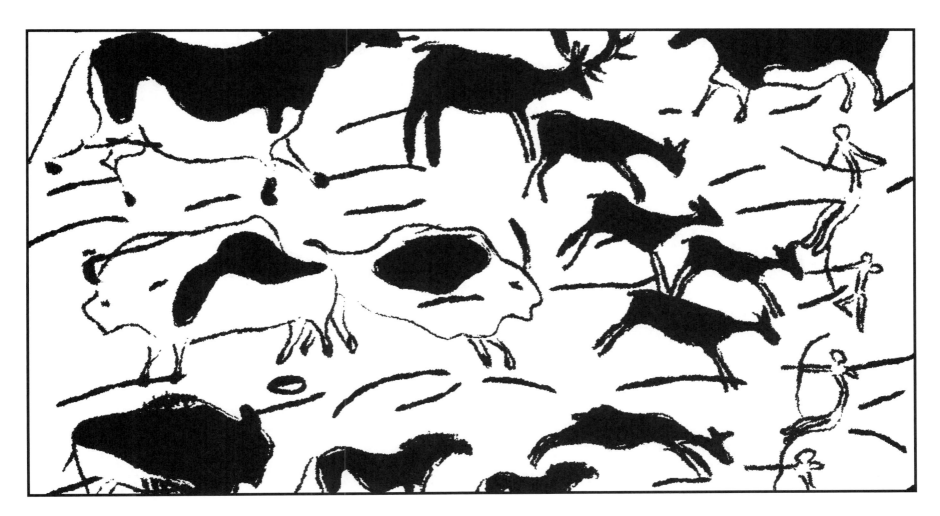

CHAPTER TWO

A SCRIPT IS A SCRIPT, ISN'T IT?

*I*t takes a writer a few years to master the art of writing in any particular medium, such as novels or screenplays. Usually, the writer begins by mastering prose writing. Some move on to other forms of writing, such as screenwriting. But "scripting," whether for stage or screen, presents different challenges to a prose writer. A familiarity with the dramatic and visual arts assists the screenwriter in shaping screenplays. Many playwrights also master screenwriting, and sometimes screenwriters go the other direction, to write "for the boards." But the other storytelling medium that uses a "script," graphic novels (or sequential graphic storytelling, or, less pretentiously, comic books), has, by and large, been regarded as a step-sibling. This is perhaps due to the history of comics having arisen from popular culture and pulp publishing.

It is easy to fall into the trap of thinking that mastering one script form automatically gives a writer the mastery of another script form. The reality is rather different. A visual artist would not make the mistake of thinking that mastering pencil drawing automatically gives mastery of wielding oil paints, or carving wood, or modeling clay. For the visual artist, the differences between the media are inescapable: the black line of a pencil or ink pen in no way does the same thing as a line of color, or a line of many colors. But for a writer, the primary tool is a vocabulary. Words, strung together in patterns, are what the writer uses to build the work of art. But although they all start with words, a novel is not a stage play, a stage play is not a screenplay, nor is a screenplay a comic script.

THE FIRST THING WE NEED TO CONSIDER IS THE NATURE OF A SCRIPT, ANY SCRIPT.

WHAT IS ITS PURPOSE?

At its most basic meaning, "script" means "something written." Writing developed as a means of capturing for posterity, or even just capturing for communication. The idea was to give the communication a permanent form that did not depend on the memory

of the messenger, a form which could be reproduced accurately, and thus shared with many people, especially those who were out of earshot of the original pronouncements. The advantages for storytellers were immediately obvious: here was a way of holding on to the special turns of phrase, startlingly effective images conjured in words, the rhythms and wordplay that each individual storyteller might come up with. From there, the possibilities of orchestrating multiple voices to tell stories inspired the beginnings of drama. A writer could compose a story for a group of people to enact, and by giving them a script of the story, the writer could ensure everyone in the group was "on the same page." And it could be repeated. Action and sound became crucial elements in that form of storytelling.

But running parallel to this text-centric form of storytelling was a visual-centric form. The earliest cave paintings were clearly intended to tell a story of sorts.

Visual storytelling has been a part of the human experience just as long as verbal storytelling. The tomb paintings of Egyptian pharaohs tell the stories of the rulers' lives, and even their journey into the underworld to face the judgment of Osiris. Many pieces of ancient Greek pottery are decorated with images

that tell parts of mythic stories: Atalanta racing her suitors and being distracted by the Golden Apples; Theseus braving the Labyrinth to fight the Minotaur; Odysseus tricking the Cyclops. All little bits of graphic sequential storytelling.

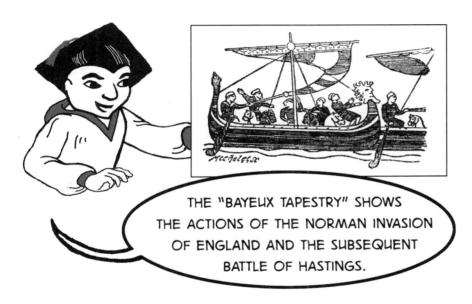

THE "BAYEUX TAPESTRY" SHOWS THE ACTIONS OF THE NORMAN INVASION OF ENGLAND AND THE SUBSEQUENT BATTLE OF HASTINGS.

During the twentieth century, the two forms of storytelling started drawing close together again. For ages they had gone their own way, running parallel courses that only rarely crossed each other. Oh, occasionally visual artists would capture moments from dramatic (or prose) storytelling, but they were almost exclusively only specific moments. The amount of labor involved in telling the whole of a story in a graphic mode was prohibitive. But various technologies developed that began to make it much easier: pens more advanced that feather quills, easier reproduction of art. By the twentieth century, many little advances made it possible for an artist to sit down and devote a mere few months to telling a whole story in a graphic form, something that could easily have taken well over a year, if not multiple years, in previous ages. Then, suddenly, the partnership of visual artist and wordsmith became important.

A novel or short story conveys its tale by strings of words, either written or spoken. A stage play conveys the story by means of sound and a limited amount of action. The boundaries of a play are set by what can be performed physically in the dramatic space. A movie conveys the story by means of sound and image and motion, and its limits are set by budget, technology, and imagination.

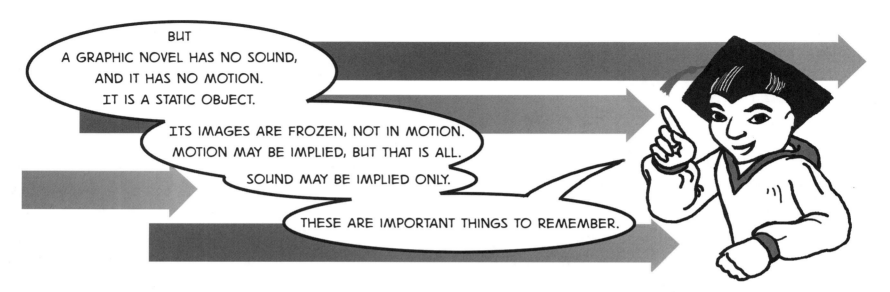

BUT
A GRAPHIC NOVEL HAS NO SOUND,
AND IT HAS NO MOTION.
IT IS A STATIC OBJECT.

ITS IMAGES ARE FROZEN, NOT IN MOTION.
MOTION MAY BE IMPLIED, BUT THAT IS ALL.

SOUND MAY BE IMPLIED ONLY.

THESE ARE IMPORTANT THINGS TO REMEMBER.

A stage script is designed to make sure that all the players know what the dialogue will be, and where each should be on the stage. The script tells the stage crew what sort of lighting is needed, what props are needed, when the curtain should be rung down.

A screenplay script is designed to let everyone know what the dialogue is, what the sequence of images should be, what locations are needed, what props are needed. The cameramen need the script, as do the costume designers and the editor. Everyone needs to have the script, so that this temporary community can produce the final story version as a unified product for the audience. The standardized form of screenplays assists in this.

But a comic script is designed so that a mere handful of people can produce the story: the artist needs it, to know what will go on each page; the letterer needs it, to know what is said by whom and in what panel; the colorist (if the work is to be in color) needs it to know how to color things; the editor needs it to oversee the storytelling.

Each type of script is a blueprint for constructing the specific form of the story. But the specific forms are very distinct.

MANY WRITERS WORK IN ONLY ONE MEDIUM, BE IT NOVEL, STAGE PLAY, OR SCREENPLAY.

THERE'S NOTHING WRONG WITH THIS, OF COURSE.

BUT A WRITER SHOULDN'T THINK THAT MASTERING ONE FORM PROHIBITS HIM OR HER FROM MASTERING ANOTHER.

THE WRITER CHOSE TO WRITE A NOVEL OR SCREENPLAY OUT OF A LOVE FOR THAT MEDIUM.

BUT NOW HE'S BEING ASKED TO RECAST THE STORY IN ANOTHER MEDIUM, ONE HE DOESN'T KNOW VERY WELL.

He may have read comic books at some point in his life, but that doesn't mean he can himself tell a story in that fashion. Still, to get to that graphic novel version he's been dreaming of, he's going to have to learn how to go sideways, and try something new.

Once you are sure you know your story and are willing to tackle learning a new storytelling medium, you are ready to begin this new adventure. If you can make the elevator pitch for your story, you should be ready to shape it into any format you want: after all, it is the *story* you want to tell, not the *medium*.

In that case, the first task is to break out the story in its most general shape, the basic structure of its beginning, middle, and end, the challenges and tests, the conflicts and the climax. Those aspects are not going to change, regardless of which medium you cast the story into.

SO, YOU'RE READY TO MOVE FORWARD THEN, RIGHT?

JUST LEARN THE NEW SCRIPT FORMAT AND GO WITH IT?

Well, no. Do you know what format the graphic form will be published in? Who is going to publish it? Will it first greet the audience in the form of the monthly pamphlets before being gathered into a single volume? Or will you go straight to the square bound long form? What about artists? Do you have an artist who does both pencils and inks? What about color, will it be in color? You need a colorist. (It doesn't have to be in color, as there are a lot of black & white books done. But it is a choice you need to make, and a black & white book is often inked differently than one that will be done in color.) And you will need a letterer, who will fill in the dialogue balloons from your script.

This book will help you with each of these matters. But they are things you need to consider before you begin scripting.

So, you've decided to give it a try, to adapt your story as a graphic novel or comic book. No matter how long it takes, or what format you need to get it into, you're going to go for it. Your final object is to get that book in your hands. And if you get so far as marketing your story to Hollywood, you want to be able to walk into the producer's office and show it to them before they haul out the dreaded "Is there a graphic novel?" question.

It can be done.

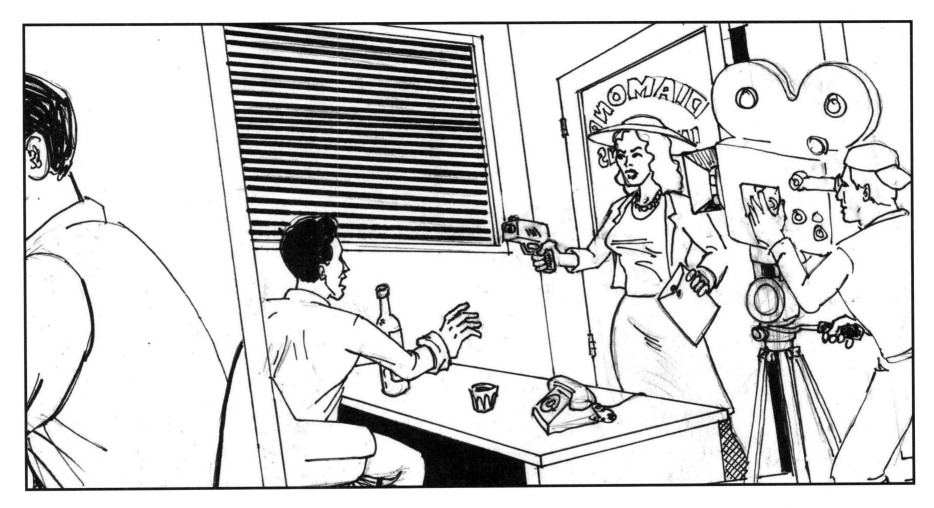

CHAPTER THREE
INTO THE GUTTERS

U nless you are really into comics, the term "**gutter**" doesn't have very positive connotations. There is the street gutter, where run-off water streams its way toward the public sewer lines. There are the gutters on the edges of house roofs, that serve a similar purpose, guiding the water that runs off the roof to a drainpipe, which further directs the run-off well away from things like doorways.

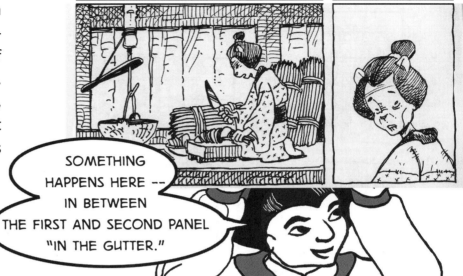

SOMETHING HAPPENS HERE -- IN BETWEEN THE FIRST AND SECOND PANEL "IN THE GUTTER."

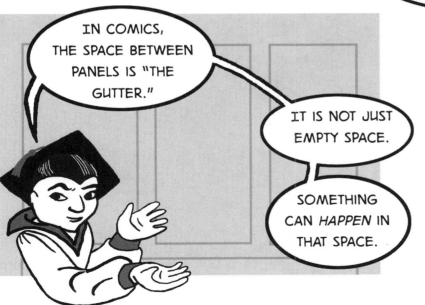

IN COMICS, THE SPACE BETWEEN PANELS IS "THE GUTTER."

IT IS NOT JUST EMPTY SPACE.

SOMETHING CAN *HAPPEN* IN THAT SPACE.

Comic scripting has its own terminology. It will help anyone desiring to write a graphic novel if they take the time to learn the terms. Before you shrug it off as a waste of your time, consider this: every arena of endeavor has its own vocabulary, the "lingo of the trade." Professionals strive to learn to talk the talk of the specific business they are working in. No one wants to be regarded as a tourist when they are trying to be professional. (And "**tourist**" actually is a term used in the comic book world: it means, specifically, a screenwriter or novelist who comes into comics without the first idea of the comic business and craft.)

The term "**comic**" or "**comic book**" is used for the form itself, whether speaking of the floppy pamphlets that get published monthly or the square bound graphic novels or collected story arcs of ongoing series. Accept your fate and get comfortable talking about your "comic book project."

The term "**graphic novel**" refers specifically to a long story, one that may be about 88 pages, if not longer (the lower limit for shorter ones is 48 pages). It is a complete story in itself. The term "**magazine**" has come to mean the monthly issues, where the story contents run about 22 to 32 pages. As you adapt your story as a graphic novel, you need to keep those monthlies in mind: it's possible your publisher will want to put the story before the audience in the monthly format first, before publishing the square bound "complete story." If that happens, you need to consider each individual issue as a chapter of your story.

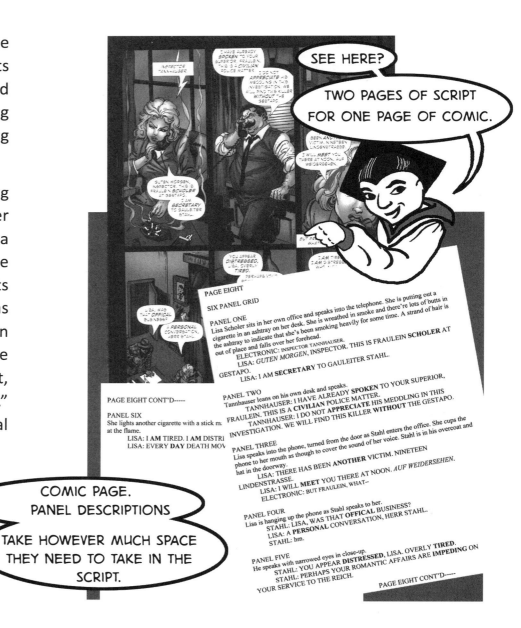

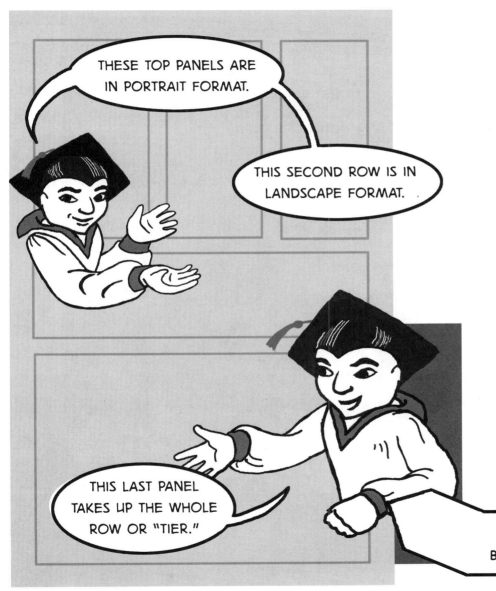

TERMS

As you get into comic scripting, the following terms will become your working tools: page, panel, gutter, splash, tier (or row), landscape, portrait, sequential, graphic, comics, magazine, funny books; artist, penciller, inker, letterer, colorist, editor.

In the past, six equal-sized panels were the standard, but that has changed as artists have developed more dynamic styles. A writer like Frank Miller (*The Dark Knight Returns*, *Sin City*, *300*) might require twelve panels on a page, to achieve a specific effect. But the current standard averages about five panels (of varying sizes) on a page.

Since the 1990s, there has been greater acceptance of "panel" art that breaks the frame of the panel. This is usually something the artist decides upon, rather than something the writer denotes. It can create a very exciting page, but it needs to be used judiciously.

The term "**sequential art**" is used to describe the graphic storytelling on the comic book page. It means the flow of the storytelling from one panel to the next, so that the imagery makes sense in the story. A series of disconnected illustrations of moments from a story does not equal "sequential art."

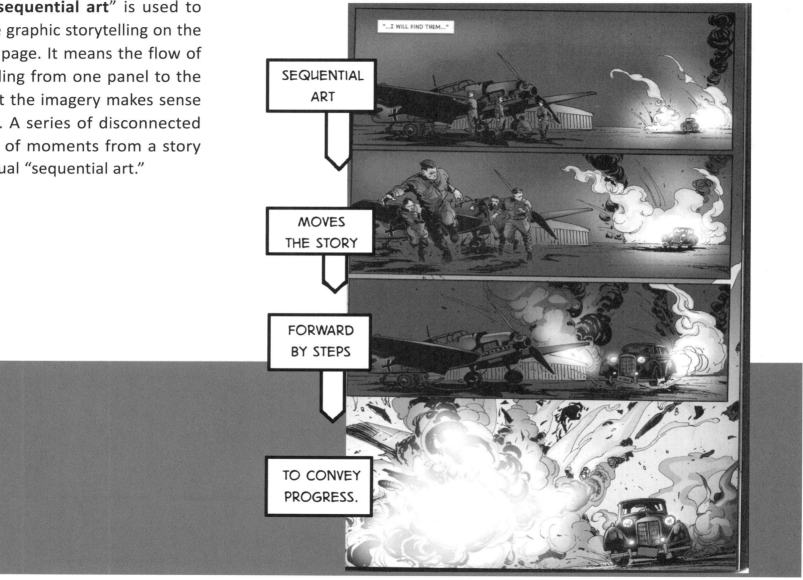

"SPEED LINES"

SPEED LINES ARE USED TO CONVEY FAST MOTION. WHETHER THEY ARE CURVING OR STRAIGHT, THEY INDICATE THE DIRECTION OF THE MOTION.

THIS IS A DIALOGUE BALLOON.

THIS IS A THOUGHT BALLOON.

THE ONLY "BUBBLES" ARE THE TAIL FOR A THOUGHT BALLOON.

NARRATIVE CAPTIONS CAN DESCRIBE SETTING, TIME, OR LOCATION.

OR THEY CAN BE USED TO CONVEY INTERNAL THOUGHTS AS AN ALTERNATIVE TO THE "CUTESY" LOOK OF THE THOUGHT BALLOON.

CREATIVE TEAM

Writers are writers, of course, and that doesn't change when you come to comic scripting. Your job remains similar to that of a screenwriter or playwright, getting the story you want to tell into the blueprint so that others can complete the vision.

The next member of the team is the Artist. And this is where you need to pay some attention.

Some comic book artists are only what are called "**pencillers**." These are artists who do all the preliminary drawing of the pages, working in pencil (hence the name). The penciller is generally your visual designer, who will set the look for the book in the way the characters appear, the nature of their wardrobes, what the world of your story will look like. They are also the highest paid of your art team. A good penciller, who delivers an exciting page with excellent detail, can spend more than a day working on one page. "A page a day" might sound like a good rule of thumb, but you have to consider what you are expecting from the artist.

The penciller might also be called the "**layout artist**," because he is providing the general lay-out for the page, which might be completed by other artists on the team.

JOE FRANKENSTEIN © NOLAN & DIXON RECREATION

Next comes the "**inker**."

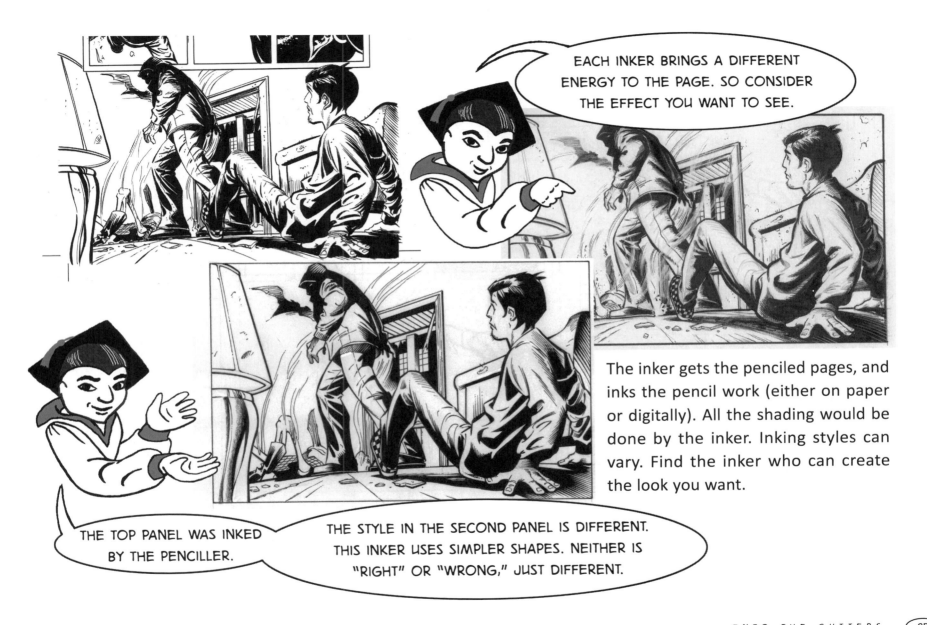

EACH INKER BRINGS A DIFFERENT ENERGY TO THE PAGE. SO CONSIDER THE EFFECT YOU WANT TO SEE.

The inker gets the penciled pages, and inks the pencil work (either on paper or digitally). All the shading would be done by the inker. Inking styles can vary. Find the inker who can create the look you want.

THE TOP PANEL WAS INKED BY THE PENCILLER.

THE STYLE IN THE SECOND PANEL IS DIFFERENT. THIS INKER USES SIMPLER SHAPES. NEITHER IS "RIGHT" OR "WRONG," JUST DIFFERENT.

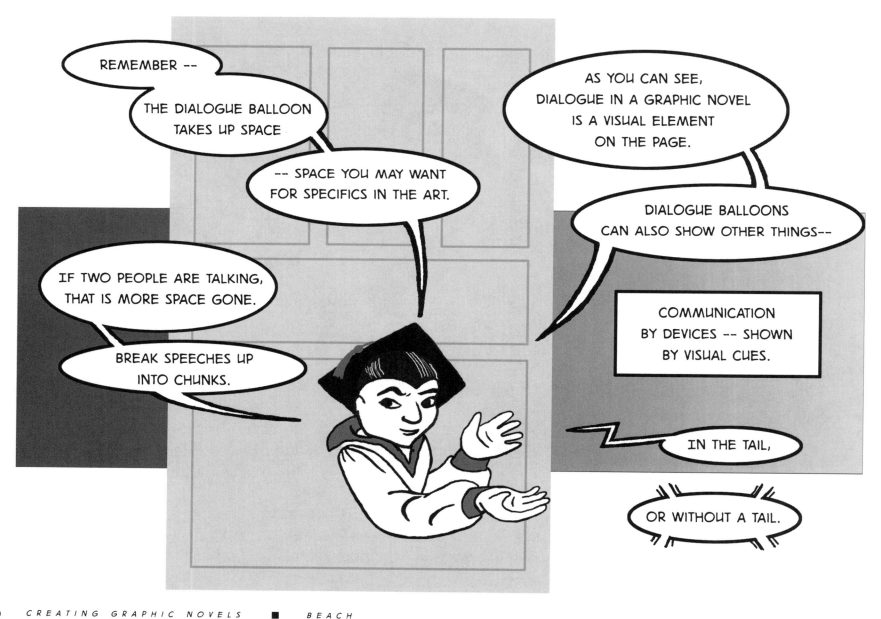

REMEMBER --

THE DIALOGUE BALLOON TAKES UP SPACE

-- SPACE YOU MAY WANT FOR SPECIFICS IN THE ART.

AS YOU CAN SEE, DIALOGUE IN A GRAPHIC NOVEL IS A VISUAL ELEMENT ON THE PAGE.

DIALOGUE BALLOONS CAN ALSO SHOW OTHER THINGS--

IF TWO PEOPLE ARE TALKING, THAT IS MORE SPACE GONE.

BREAK SPEECHES UP INTO CHUNKS.

COMMUNICATION BY DEVICES -- SHOWN BY VISUAL CUES.

IN THE TAIL,

OR WITHOUT A TAIL.

The next on the team, if you are going to be doing a color book, will be your "**colorist**." These days, almost all coloring for graphic works is done on computer. But that does not mean that all colorists are equal. Some are better at it than others, so you need to check their work.

Your art team, and your inker in particular, will need to know if the final book will be color or black & white, since it affects the final look of the page. If the inker knows the book will not be colored, there are things he can do in the inking to increase subtlety in the images. If he knows that your Dorothy's special slippers will not be colored a bright, obvious red, he will find ways to ink them so that they will look like the glistening silver that L. Frank Baum intended.

The final member of the art team is the "**letterer**." This is the person responsible for getting all the dialogue balloons into the panels, and making sure the balloon tails all point to the correct character.

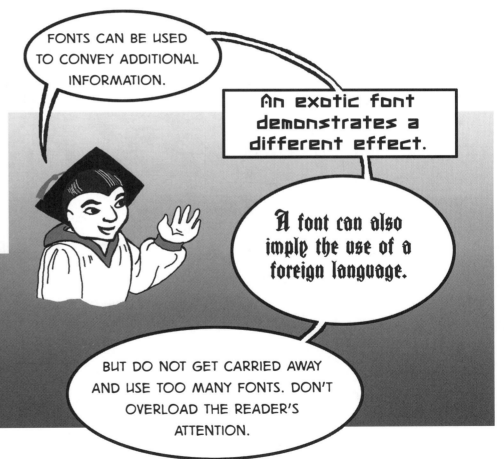

FONTS CAN BE USED TO CONVEY ADDITIONAL INFORMATION.

An exotic font demonstrates a different effect.

A font can also imply the use of a foreign language.

BUT DO NOT GET CARRIED AWAY AND USE TOO MANY FONTS. DON'T OVERLOAD THE READER'S ATTENTION.

FORMAT

Do you know how your story will be published? Will it be in monthly installments? If so, what will the monthly page count of the comic be? Twenty-two pages or something more?

> YOU NEED TO PLAN YOUR PACING IN CHAPTERS. THAT WAY, IF THE PUBLISHER WANTS TO DO IT AS A MONTHLY, YOU'LL BE READY.

> A COMIC BOOK PUBLISHER MAY WANT TO TEST THE MARKET BY FIRST PRINTING YOUR TALE AS A LIMITED SERIES IN THE MONTHLY FORMAT.

"Why can't the artist do the script?" you ask.

"Why can't I just give the artist the story (whether screenplay, short story, or novel)?" The blunt answer is that it is the writer's job to do that. The artist is already committing a day of work (at least) to produce one page of art for you. Asking the artist to provide the blueprint for the rest of the team as well means that you are asking him to do two jobs instead of one. Are you willing to pay the artist double for that?

Once the print format has been decided, you can plan the pacing of your story. Knowing the number of comic pages you will have, you can plan your cliff-hangers. You will know how many pages you have leading up to the hook that ends each "chapter." And you can anticipate the placement of visual elements in each two facing pages. (We'll touch on this in more detail in the next chapter.)

GETTING INTO THE COMIC SCRIPT

The artist is your first audience for your comic script. By "first audience" I mean that it is the artist that you will need to engage the most with your script.

If the story is already written, this should be easy, shouldn't it?

> IF YOU TRUST YOUR STORY, YOU CAN TELL IT IN ANY FORMAT, INCLUDING A GRAPHIC NOVEL SCRIPT. SO MAKE IT EXCITING FOR YOUR ART TEAM.

> KNOW THE HEART OF YOUR STORY, AND YOU'LL BE ABLE TO ADAPT IT TO ANY FORMAT.

For writers who are intending to adapt a "non-script" story, the demands of the different formats of comic scripting are accepted as "new rules." The clueless-about-comics screenwriter, however, might ask if he can't just give the artist a copy of the screenplay. But we've already touched on one of the problems in this: you'd be asking the artist to become the comic scripter on top of the job you hired him for. And again, unless you are willing to pay for the double duty, don't try it. (Most artists will probably refuse it anyway.)

So, you sit down and make the changes to your story needed for this new form of storytelling. You break up your scenes into those panel descriptions and pare down the dialogue. Now you're ready to rock. At least, you think so.

CAUTION: DANGER AHEAD

There are two (almost standard) complaints from artists and editors about the comic scripts from those storytellers who are new to writing graphic novels.

The first complaint is that there is too much happening in one panel, to the degree that it isn't going to work, no matter how hard the artist tries.

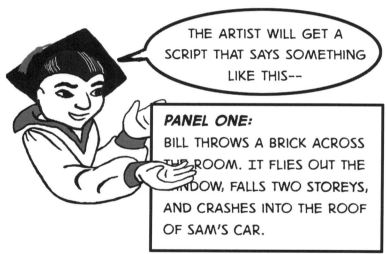

THE ARTIST WILL GET A SCRIPT THAT SAYS SOMETHING LIKE THIS--

PANEL ONE:
BILL THROWS A BRICK ACROSS THE ROOM. IT FLIES OUT THE WINDOW, FALLS TWO STOREYS, AND CRASHES INTO THE ROOF OF SAM'S CAR.

The artist will look at this description and despair. The action described is a simple enough thing in film (although it would probably involve at least two camera set-ups).

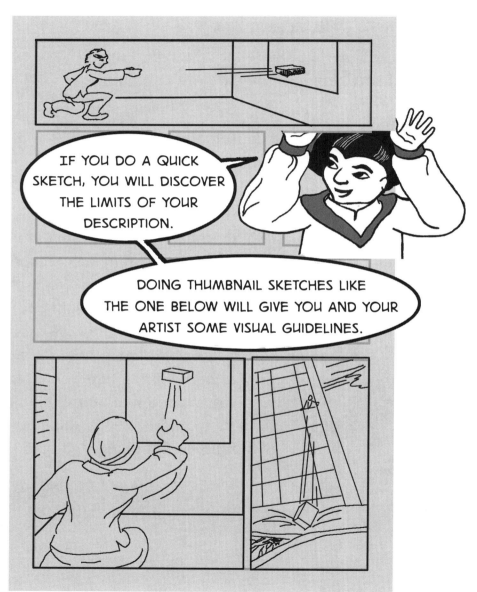

IF YOU DO A QUICK SKETCH, YOU WILL DISCOVER THE LIMITS OF YOUR DESCRIPTION.

DOING THUMBNAIL SKETCHES LIKE THE ONE BELOW WILL GIVE YOU AND YOUR ARTIST SOME VISUAL GUIDELINES.

The second complaint about the scripts of novice graphic novel writers is too much talking. Talk, talk, talk.

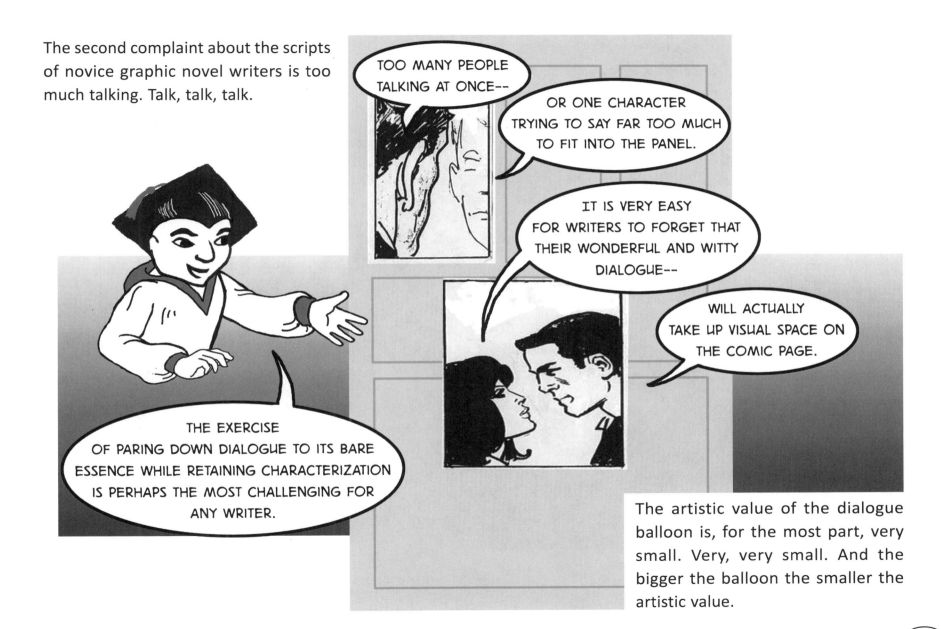

TOO MANY PEOPLE TALKING AT ONCE--

OR ONE CHARACTER TRYING TO SAY FAR TOO MUCH TO FIT INTO THE PANEL.

IT IS VERY EASY FOR WRITERS TO FORGET THAT THEIR WONDERFUL AND WITTY DIALOGUE--

WILL ACTUALLY TAKE UP VISUAL SPACE ON THE COMIC PAGE.

THE EXERCISE OF PARING DOWN DIALOGUE TO ITS BARE ESSENCE WHILE RETAINING CHARACTERIZATION IS PERHAPS THE MOST CHALLENGING FOR ANY WRITER.

The artistic value of the dialogue balloon is, for the most part, very small. Very, very small. And the bigger the balloon the smaller the artistic value.

It could be very easy for the writer to start thinking at this point that making this metamorphosis from screenplay, novel, or short story to graphic novel just isn't going to work.

IF THE "PRO" OPTIONS ARE WORTH IT, THE STORYTELLER WILL HAVE TO PRESS ON.

BUT...
THE GROWING POPULARITY OF GRAPHIC NOVELS CREATES AN ENTICING OPPORTUNITY FOR AUDIENCE GROWTH.

FOR SCREENWRITERS, TO ANSWER THAT "SEE THE BOOK" QUESTION MAY PRODUCE A FEELING OF BEING BETWEEN A ROCK AND A HARD PLACE.

AGE OF BRONZE™
SACRIFICE
ERIC SHANOWER

The Story of the TROJAN WAR

The solution is to learn more about the nature of the comic book and its graphic sequential storytelling. It is not impossible.

The first, most important thing for the writer to remember is that the desired end product is a *book*.

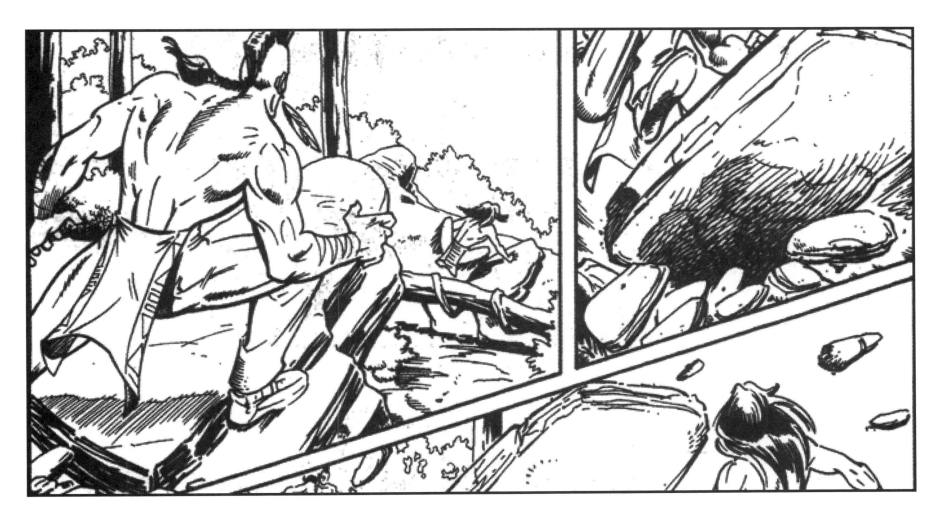

CHAPTER FOUR
IS THERE A BOOK?

Screenwriters are used to thinking of their story in terms of the moving visual images within a space of time. This makes them focus on the fluidity of motion within a scene, as well as how long it takes for dramatic moments to occur. Novelists (or prose writers) think of their stories in the context of how their language shapes the emotional impact of the story. Those who work in prose dwell on how the words themselves build the pace of a moment in the story.

But for storytellers using the medium of graphic sequential narration, there are additional concerns. In particular, the storyteller has to be concerned about the physical nature of the medium itself.

"But a prose book is a physical object too," someone protests.

Well, yes and no. Most prose work does indeed reach the audience in the form of text on a page (or screen, what with e-books these days). But the important element of prose is the actual words themselves. The story would have equal impact if read aloud — hence the popularity of audio books, which are an atavistic return to the oral tradition in storytelling.

But a graphic novel or comic book inherently combines the visual imagery in a static form with the words in a visual form. The storyteller is working in a medium which has the end result of the creative process in a physical object.

IF YOU'RE GOING TO WORK IN THIS MEDIUM,

YOU NEED TO KEEP IN MIND THAT YOUR END PRODUCT IS--

A BOOK.

(We will touch on the natures of motion comics and digital comics at the end of the chapter, but those are still built on the foundational understanding of the physical print book.)

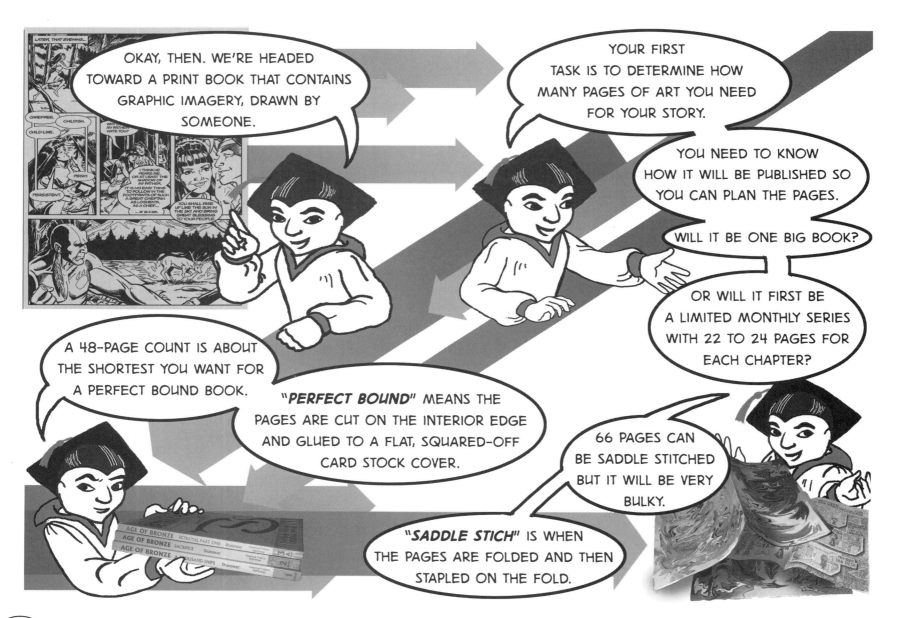

BUDGET

ITEM	QUANTITY	UNIT COST	TOT...
Pencils	88	$XXX a page	$X,XXX
Inks	88	$XX a page	$XXX
Letterer			
Colorist			
Printing			
Binding			
Shipping			
Advertising			
Website			

FIGURE OUT THE KEY THEME FOR EACH OF YOUR GRAPHIC CHAPTERS.

OUTLINE

PART ONE
Boy meets girl
HE HELPS HER AFTER SHE LOSES BF

PART TWO
Boy wins girl
SHE SEEMS THE GIRL OF HIS DREAMS

PART THREE
Boy loses girl
HE THINKS SHE'S SEEING SOMEONE ELSE

PART FOUR
Girl comes after boy to kill him
SHE TURNS PSYCHO – SHE KILLED PREVIOUS BF

When your desire is to really impress the reader, you want to give them the sharpest product possible. But the final consideration for you may be the production cost, so you do have to keep these details in mind as you lay out your plans. Perfect binding is likely to cost more than saddle stitching.

In any case, you have to decide how many pages you want your graphic novel to run. If you feel your story will work in 88 pages, that means you have four chapters of 22 pages each. If you want to stretch your story longer, say to 132 pages, you are dealing with six chapters of 22 pages.

Prose writers who choose to do a graphic novel adaptation of their work simply to expand their audience may not care about the Hollywood producer's attitude, but a screenwriter going this route will. Let's remember that in that situation what we are after is a positive answer to the film producer's question: "Is there a book I can see?" You want to have a product you can put into that producer's hands in order to juice up your pitch. And you want it to be a story that will hook an audience.

With that in mind, you need to evaluate your tale for the points that will really stand out in the graphic novel form. Is it a really good story? Well, since you've been trying to get it in front of as large an audience as possible, we can assume you believe that it is. Will readers get into it? Again, you're a believer. So how big a book do you want it to be?

You need to keep the size of your story in mind. For a screenplay, the writer considers how long images and scenes will last on the screen, and they make sure that scenes do not run too long and start getting boring. A similar consideration applies to comic scripting.

For the moment, let us assume that you have the funds for a top-notch art team, that you will be doing it in color, that it will be printed on high-grade paper with perfect binding. And for the purposes of examples here, you are working on a four-part (or four-chapter) story. You've decided your tale can work in four sections, and you're ready to retool it into a comic script.

The first thing you need to make certain is that the endings of your first three sections stop at a cliffhanger moment. You *want* your reader to be left at the end of the chapter with a "Wait, what!? What happens *next*?" experience. In terms of plot description of the story, using the model of screenplays, then, it is likely that the first chapter of your graphic novel will end just before the end of your First Act, just before your hero makes the decision to commit to whatever quest your story will take him on. You want

YOU DO NOT WANT LONG SEQUENCES OF TALKING HEADS --

NOT PAGE AFTER PAGE.

YOU ARE WRITING FOR IMAGES TO CARRY AS MUCH OF YOUR STORY AS POSSIBLE; *INTERESTING* IMAGES.

the chapter to end at an unbalanced point, without resolution, so that the reader is tipped forward into the next section of the story. This is true for the endings of each section except the last. Do not give away where the story turns next. Instead, make the answer of that question a driving issue for the reader.

Once you know that point for the end of the chapter, you know what it is you are driving toward in all the pages that come before it. It is *necessary* to determine this point, because it shapes the pacing of how you get to it.

Which brings us back to the physical nature of the comic book. We are talking about pages here, physical pages. Right-hand and left-hand pages, pages that

face each other, lying side by side when the book is open, and then pages that are hidden by a physical turn of the page. This physicality can be used to affect suspense and tension in your story, to put in surprise transitions from one scene to another. You can suspend the resolution of one scene by interposing something else behind the turn of the page.

Generally speaking, all sequential art storytelling begins on a right-hand page, Page One. And a book or a chapter will end on a left-hand page, an even-numbered page. As you prepare to block out your comic scripting, these are points you need to keep in mind. We will go into greater depth about the actual scripting for comics in Chapter 5. But for now, what you need to get a sense of is where the dramatic moments for this chapter come in your story.

If you want your last page of the chapter to be a highly dramatic moment, you and your artist may choose to give that last page over to a single panel image. *Charlie is blown off the cliff.*

THESE PANELS INVOLVE A REAL CLIFFHANGER. WHAT'S GOING TO HAPPEN TO OUR HERO?

THIS WAS ON THE BOTTOM OF A RIGHT-HAND PAGE. THE BIG REVEAL CAME AFTER THE PAGE TURN.

Elsewhere in the chapter, you may have a dramatic revelation that you want to give a full page, a reveal that comes after a suspenseful page turn. Make note of that commitment of space. But don't overdo the business of assigning too many full-page spreads.

They should be used sparingly, for genuine dramatic moments. Put too many into a chapter and the reader may feel that the writer is being lazy about the story-telling. But be sure you are using the large space for what is the genuine drama.

YOU NEED TO FIGURE OUT HOW MUCH **"PAGE SPACE"** EACH MOMENT OF YOUR STORY WILL TAKE UP.

Page 1 RIGHT
ESTABLISH HERO WANTING A GIRL-FRIEND. CREDITS

Page 2 LEFT
HERO & BEST FRIEND, SEEN AT COLLEGE. GIRLS PASSING BY.

Page 3 RIGHT:
FULL PANEL: CUTE MEET OF HERO & GIRL – BUMP INTO HER.

Page 4 LEFT
SEQUENCE OF DATES: SHE TALKS ABOUT LAST BF, HERO ENCHANTED

Page 5 RIGHT
HERO'S SISTER WARNS ABOUT GIRL & GIRL WANTS TO SLOW DOWN.

Page 6 LEFT
HERO STAGES BIG ROMANTIC MOOD LIT DATE. WINS GIRL.

Page 7 RIGHT
GIRL AWAY. P.I. SHOWS UP, LOOKS FOR HER LAST BOY-FRIEND, MISSING.

Page 8 LEFT

Page 9 RIGHT

Page 10 LEFT

Page 13 RIGHT

Page 14 LEFT

Page 15 RIGHT

Page 18 LEFT

RIGHT

You can use an index card program. Set up a file of 22 cards or blocks, one for each page of the final comic book. Color code them in a simple fashion, white for right-hand pages and a pale yellow for the left-hand pages, for instance. This lets you see all 22 blocks at once, including the placement of pages with special, specific images.

Every writer will find their own way to achieve this end result. You might use a spreadsheet program and use alternate highlighting for even and odd pages. Or simple lined paper with a single line for each page and some sort of indicator for the even and odd comic pages. But however you do it, this preliminary decision-making will help you when you get into the nitty-gritty part of adapting your story to the comic script. It is useful for structuring *any* story for the graphic novel form.

Once you've done this much outlining (for yes, this is a type of outlining of your story), you can set it aside for the moment, at least in the sense that you're not going to be adding more script information yet.

When you search for your art team, you want to be able to say "I have this moment when we see this character lose — or think he has lost — the love of his life." Or "There's this one moment that I want to be as scary as all get out! Something big and dark and dangerous coming out of shadows. And then we turn the page and reveal—"

THE REASON TO DO THIS MUCH UPFRONT...

IS SO YOU CAN MORE EASILY ENGAGE YOUR ARTISTS IN THE PROJECT.

YOU WANT TO EXCITE THEM.

YOU WANT YOUR ART TEAM TO SHINE ON THE PAGE. YOU WANT THEM TO MAKE YOUR STORY LOOK DAZZLING.

Because when the person who asked "Is there a graphic novel I can look at?" finally opens the covers of your graphic novel, you want them to be blown away with your story. And to get there, you have to do that to your art team.

Presentation is everything. If you care so little about your story that you find the first artist you can afford, toss them your novel or screenplay and say "Make a graphic novel out of this, please," what is the artist to think concerning how much this means to you? What do you consider the important moments in the story? If you aren't going to do the work of preparing a comic script for the artist to work from, you will get what the unguided *artist* finds of interest.

STEP TWO:
KNOW WHAT SORT OF *"LOOK"* YOU ARE GOING TO WANT FOR YOUR GRAPHIC NOVEL.

SO, STEP ONE:
KNOW WHAT THE DRAMATIC MOMENTS OF YOUR STORY ARE AND WHERE YOU WANT THEM TO FALL IN YOUR GRAPHIC NOVEL.

Knowing what the "look" of your book will be involves your second big consideration for the physical production of the work. Where the first was the number of pages and the binding that will be used, the second is whether or not you will do the interior work in color or black & white. This is not just a haphazard choice. It is a factor the artist needs to know.

When the artist knows a work will be printed in color he may make different choices about composition than he would if he knows it will be just in black & white. Be sure you have budgeted for your colorist from the beginning, because if you have a penciller

and inker who thought the work would be colored after they were done, and you suddenly run out of money and decide to go ahead "as is," they might not be so happy with the work. This is not about them not "doing their best," it is about the huge differences that exist in drawing for color and drawing for black & white. Certainly, it is possible to color black & white work after the fact, and not have it be much of a serious compositional problem. But to go in the other direction can be a problem, particularly for your inker. For instance, an inker who knows that the page will be colored might ink in night-shadows differently than she would if she knew it was going to be printed in a flat black & white (or greyscale).

Once you have resolved the matter of color versus black & white printing, your next consideration should be your letterer. There is indeed an art to lettering a work of graphic storytelling. The selection of fonts can be an important enhancement to the storytelling, especially if your story is outside the mainstream literary genre. If your tale involves science fiction or fantasy or supernatural elements, having a letterer who knows how to suit font selection to the character and story will be a great advantage to you.

DON'T FALL INTO THE TRAP OF THINKING YOU CAN "DO IT YOURSELF" IN PHOTOSHOP, WITH THAT INFAMOUS "COMIC SANS" FONT.

To address the specific matter of Comic Sans font: never use it in a graphic novel. Ever. It is not actually an accepted font for comic books. It is a misguided font designer's misapprehension of what comic book lettering actually does and is.

This is Comic Sans font. Most text in graphic novels is done in BLOCK CAPITAL LETTERS. BUT THEY DO NOT USE THE CAPITAL /I/ IN THE MIDDLE OF WORDS. As you can see, Comic Sans does this. It doesn't look good. It stands out like a sore thumb.

A good letterer will understand the need for clarity in selection of a font for your work. The object is for the text to communicate clearly, without drawing too much attention to itself. If a reader is spending too much time going "What the heck is this word?" because the font is too "artistic," it's the wrong font for the job.

However, there may be occasions when to better serve your story, a different font might be used for specific situations or characters.

Perhaps you are telling a science fiction story with a sentient computer as one of the characters. The distinctive nature of the computer can be indicated visually by giving its declarations a different font than the one being used for all other dialogue and captions.

Such artistic choices can add greatly to the reader's experience of your story.

For most writers, all of these elements are new considerations in the storytelling. A graphic novel is visual in some crucially different ways than a movie is visual. For a film, the images have motion and the dialogue has sound. The words that are necessary in the final product for the storytelling do not take up physical or visual space. But those same words in a graphic novel *do* have a physical presence, and they must be included in the over-all design.

It is likely to be a new experience for most writers to have to consider design issues, but such is the case when it comes to putting together a graphic novel. The choices for an art team (or single artist, if you find one who will do all the visual chores including lettering) are important, for you are entering into a partnership.

THE ART TEAM WILL BE PUTTING FLESH AND BLOOD ON THE BONES OF YOUR STORY,

AND YOU WILL WANT TO BE SURE IT IS THE RIGHT FLESH AND BLOOD.

Remembering all of the elements that will be on the page is important when you hunt for the right artist. If you have a lot of dialogue that absolutely must be included, that excellent artist with the energetic and busy style might not be the right choice for the project. Your object is to make the experience of reading the graphic novel as seamless as possible, so you do not want the dialogue balloons and the artwork fighting each other for the attention of the reader. The two elements should work together.

You might feel at this point that the undertaking of turning your story into a graphic novel was a mistake. You start wondering if the story actually can be adapted as a graphic novel. Don't be discouraged. The form is adaptable to different styles and tones. You just need to make some decisions about the adaptation.

Writer CJ Hurtt speaks from his experience in adapting a property.

YOU ADAPTED 2 NOVELS FROM A SERIES INTO ONE 140-PAGE GRAPHIC NOVEL. WHAT SORT OF DIVISIONS DID YOU SET FOR THE GRAPHIC NOVEL?

The series that we based the GN on is a trilogy and we didn't know how many GNs we would be able to do. If the GN proved unpopular, we didn't want to get stuck with a half-told tale and unable to produce an expensive book in order to finish it. So, we looked ahead in the series to get an idea of where the story was going. We wanted to create an ending that could serve as the actual ending of the story, but also keep the door open for a sequel if we got the chance to make one. We used the second novel for a few key scenes and elements that would allow us to do that. We could wrap up some, but not all, of the loose ends in our adaptation of the story in a single volume.

HOW DID YOU CHOOSE ELEMENTS OR EVENTS FROM THE 2 ORIGINAL BOOKS FOR THE GRAPHIC NOVEL? WHAT DID YOU LOOK FOR IN DECIDING WHAT TO INCLUDE?

I looked for the major themes. I really wanted to get across what the author of the novel series intended. Since so much of the source material would not be

in the GN due to space, it became very important to make sure that his vision of the world he created wasn't totally washed away. Any scene that reinforced his major themes was bookmarked and reviewed to see how we could use it and how many pages it would take to produce the scene. The novels contain a lot of action and violence. We obviously could not include all of the battles and fighting and still have room left over for story, so any battle that didn't provide a decisive outcome had to be cut. Giant chunks of the story had to be moved around and rearranged to make this work. When doing an adaptation like this, at some point you have to stop looking at it as if you are creating storyboards for a novel. A lot of story elements may have to change in order to bring the novel in the sequential form. You have to be very economical with words, action, everything. Sometimes you have to view it as "your version" and make changes so that it works as a comic.

We ended up cutting a lot of the characters and combining more than a few. You look at the role some of the characters play and see if there's any overlap. If three guys are the "buddy" maybe you can cut that down to one. Minor characters whose arcs don't greatly affect the main story arc could usually be cut. That's not to say that we didn't have a subplot, but it really is a bad idea to have a cast of thousands in a self-contained 140-page GN. I did invent a couple of characters, but they were fairly minor. Sometimes you need a plot device person that does something noteworthy and you don't have one in the established list of characters. The characters where we combined people sometimes needed to have their "voice" changed a bit. We had a few characters that served similar purposes, but had different personalities. So in a sense they get invented as you adapt them to the GN script from the novel.

DID YOU HAVE TO LEAVE CHARACTERS OUT? OR ADD ONES THAT DIDN'T EXIST IN THE ORIGINAL MATERIAL?

ALTHOUGH THE PHYSICAL BOOK FORM REMAINS THE PRIMARY FORMAT FOR COMICS,

DIGITAL FORMATS HAVE BEEN TAKING SHAPE.

The simplest form of this consists of straight scans of print pages, so that the image on screen is that of the specific page imagery. There are other developments, however. "Motion comics" as well as comics designed specifically for the e-book experience.

A **motion comic** combines a visual recording of the artwork with simple animation. Specific panels may be expanded to show the whole artwork of the panel. Narration captions and dialogue balloons are also usually removed in order to better show the artwork. Sound effects and voice acting are added. The format has had a mixed reception, because the storytelling proceeds at the speed the producer has chosen.

However, as a tool for building your audience, short teasers of the story in the form of a motion comic can be worth considering.

There is growing activity in comics specifically designed for the digital experience. Noted writer Mark Waid has actively engaged in the endeavor, as one of the founders of the Thrillbent website. Instead of animation, these digital comics use technology to get more effect out of the panel art, such as rendering a foreground in sharp focus with the background blurred, while a foreground character speaks or acts, and then on a second swipe of the screen the reader gets the same panel, but with changed focus, so that whatever is background becomes the center of attention.

THESE ARE NEW WAYS OF PRESENTATION, BUT BY AND LARGE, PRINT STILL SHAPES THE NATURE OF GRAPHIC SEQUENTIAL STORYTELLING.

CONSIDER WHAT YOUR PRIMARY AUDIENCE WILL BE, HOW RECEPTIVE THEY MIGHT BE TO AN ALTERNATE FORM OF DELIVERY,

AND MAKE YOUR PLANS ACCORDINGLY.

THE BEST OPTION IS TO PLAN FOR PRINT AND KEEP THE ADDITIONAL FORMS OF DISTRIBUTION AS SUPPLEMENTARY OPTIONS.

Stick with your determination to complete the graphic novel. Find the art team that best suits your inclinations, and trust them. A good artist will often see something in your material that you do not, and will surprise you with an insightful touch.

The important thing to remember is that the object is to get the reader — whoever it might be (that general reader or the Hollywood producer who might want to make a film) — entirely engaged in your story, to the point that they want more of it. Art that merely gets the story on the page is not going to do the job for you. You want a book that piques the reader's curiosity from the start, with an engaging cover image. Then the pages and panels inside need to keep the reader hooked, so that they want to know what happens next, they want to know if there is more.

(And after all, that is what the Hollywood producer is looking for too: something that holds onto the audience.)

CHAPTER FIVE

PANEL BY PANEL

Getting into the nuts-and-bolts of comic scripting starts with understanding the multiple ways it can come about. For those who are more used to the strict formatting regimentation of screenwriting, the fluid options of comic scripting can be a little bit unsettling. But even within that fluidity there are certain basic things to be grasped in order to do the job of writing a comic script well.

WITHIN THE COMICS INDUSTRY THERE ARE TWO BASIC METHODS FOR SCRIPTING.

ONE IS CALLED THE *"FULL SCRIPT METHOD."*

THE OTHER IS CALLED THE *"MARVEL METHOD."*

The **"full script method"** is similar to the process of writing a film script. The writer composes the whole plot line, writes the panel descriptions and dialogue, making sure everything is as clear as possible. And then, usually, washes his hands of the rest of the task. The script goes to the editor (if there is one) who makes sure it reads intelligibly. And then it goes to the penciller and the rest of the art team. The penciller creates the art based on the descriptions in the script and everything moves onward through the process.

The full script method has become more popular throughout the business, because it allows the writer to move onward with additional projects. He's not usually going to be involved in details of what the art team does, unless he originated the project and has a proprietary interest in the book's existence.

The **"Marvel method,"** as the name indicates, developed at Marvel Comics. In this case, the story is usually beaten out first, into a general outline of what is to happen, the types of conversations characters are going to have, and what other things may need to be included in the visuals for the story. This filled-out treatment is then given to the artist who creates

all the visuals for the story. This then returns to the writer, who only *now* addresses the matter of dialogue, having to make the dialogue fit the available space that the artist has provided.

The Marvel method can work well if the writer and artist are the same person. It can work well if the two team members have a good rapport with each other and get along when under pressure. It does become more laborious for other situations, though. The dialogue must now be made to fit the artwork, whether or not the artist has left room for long speeches or verbal exchanges.

One of the first things that can intimidate a writer new to graphic novels is that there is no set standard for the form of the script. There are almost as many presentation methods as there are comic book writers. But whatever "look" you choose for your script, there are some key elements that need to be included.

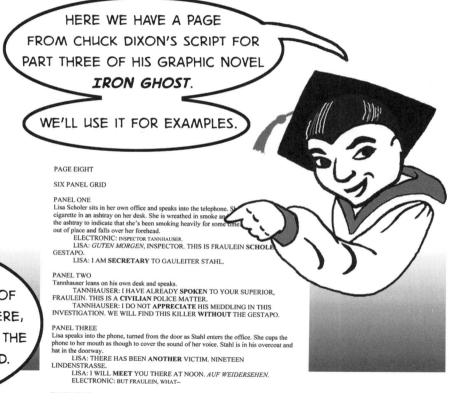

THE WRITER NEEDS TO LET THE ARTIST KNOW WHICH PAGE THE DESCRIPTIONS AND ACTIONS WILL BE ON. THE PAGE NUMBER REMINDS THE ARTIST THAT IT WILL BE A LEFT OR RIGHT-HAND PAGE, SINCE THAT AFFECTS THE COMPOSITION OF THE PAGE.

GIVE THE ARTIST AN IDEA OF HOW MANY PANELS YOU WANT ON THE PAGE. A **"GRID"** MEANS THE PANELS ALL WOULD BE ABOUT THE SAME SIZE AND SHAPE.

YOU DON'T NEED LOCATION SLUGLINES FOR EACH PANEL. BUT YOU DO NEED TO INDICATE WHERE EACH PANEL SCENE TAKES PLACE.

IN A COMIC SCRIPT, THE PANEL IS THE SPECIFIC UNIT OF STORY-TELLING.

IT CAN BE ACTION YOU WANT TO CONVEY.

OR IT MIGHT BE THE EXPRESSION OF A CHARACTER. A PANEL IS NOT NECESSARILY A WHOLE SCENE IN ITSELF.

IT'S A SPECIFIC MOMENT.

PAGE EIGHT

SIX PANEL GRID

PANEL ONE
Lisa Scholer sits in her own office and speaks into the telephone. She is putting out a cigarette in an ashtray on her desk. She is wreathed in smoke and there're lots of butts in the ashtray to indicate that she's been smoking heavily for some time. A strand of hair is out of place and falls over her forehead.
 ELECTRONIC: INSPECTOR TANNHAUSER.
 LISA: *GUTEN MORGEN*, INSPECTOR. THIS IS FRAULEIN **SCHOLER**, GESTAPO.
 LISA: I AM **SECRETARY** TO GAULEITER STAHL.

PANEL TWO
Tannhauser leans on his own desk and speaks.
 TANNHAUSER: I HAVE ALREADY **SPOKEN** TO YOUR SUPERIOR, FRAULEIN. THIS IS A **CIVILIAN** POLICE MATTER.
 TANNHAUSER: I DO NOT **APPRECIATE** HIS MEDDLING IN THIS INVESTIGATION. WE WILL FIND THIS KILLER **WITHOUT** THE GESTAPO.

PANEL THREE
Lisa speaks into the phone, turned from the door as Stahl enters the office. She cups the phone to her mouth as though to cover the sound of her voice. Stahl is in his overcoat, hat in the doorway.
 LISA: THERE HAS BEEN **ANOTHER** VICTIM. NINETEEN LINDENSTRASSE.
 LISA: I WILL **MEET** YOU THERE AT NOON. *AUF WEIDERSEHEN.*
 ELECTRONIC: BUT FRAULEIN, WHAT--

PANEL FOUR
Lisa is hanging up the phone as Stahl speaks to her.
 STAHL: LISA, WAS THAT **OFFICAL** BUSINESS?
 LISA: A **PERSONAL** CONVERSATION, HERR STAHL.
 STAHL: hm.

PANEL FIVE
He speaks with narrowed eyes in close-up.
 STAHL: YOU APPEAR **DISTRESSED**, LISA. OVERLY **TIRED**.
 STAHL: PERHAPS YOUR ROMANTIC AFFAIRS ARE **IMPEDING** ON YOUR SERVICE TO THE REICH.

 PAGE EIGHT CONT'D-----

In the comic script, dialogue is indicated by specifying which character is speaking. This tells the letterer who the balloon tail will have to point toward. However, if the dialogue is coming from a device such as a telephone or radio, you need not specify the character that is speaking. It is more important to indicate that it is from a device, because again, that is information the letterer will use to shape the balloon choice. Multiple speaker designations of the same character in a row tell the letterer that each unit of dialogue should be presented in a separate balloon.

Note also that emphasis in the dialogue can be conveyed by putting the emphasized words in **boldface.**

As you can see, in the case of a comic book script, it serves as a blueprint so each member of the creative team understands what they need to do for the best result.

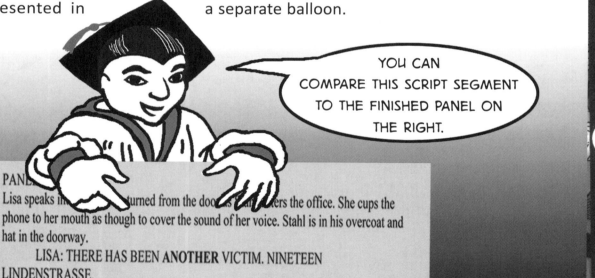

YOU CAN COMPARE THIS SCRIPT SEGMENT TO THE FINISHED PANEL ON THE RIGHT.

PANE
Lisa speaks in ... turned from the doo... ...ters the office. She cups the phone to her mouth as though to cover the sound of her voice. Stahl is in his overcoat and hat in the doorway.

LISA: THERE HAS BEEN **ANOTHER** VICTIM. NINETEEN LINDENSTRASSE.

LISA: I WILL **MEET** YOU THERE AT NOON. *AUF WEIDERSEHEN.*

ELECTRONIC: BUT FRAULEIN, WHAT--

THERE HAS BEEN *ANOTHER* VICTIM. NINETEEN LINDENSTRASSE.

I WILL *MEET* YOU THERE AT NOON. AUF WEIDERSEHEN.

BUT FRAULEIN, WHAT--

Once you establish a workable rhythm for yourself, using a script method that best helps you communicate your key expectations on what the story will look like, you can then return to the matter of pacing the story.

We've touched on the matter of writing for the page turn, and how it can be used to build suspense in your storytelling. You need to mark down where you want those moments to fall. Additionally, there may be moments that you want to have a bigger visual presence. Figure out where those would come. Likewise, find where there are scenes or sequences you know would be best encountered by a reader on two facing pages.

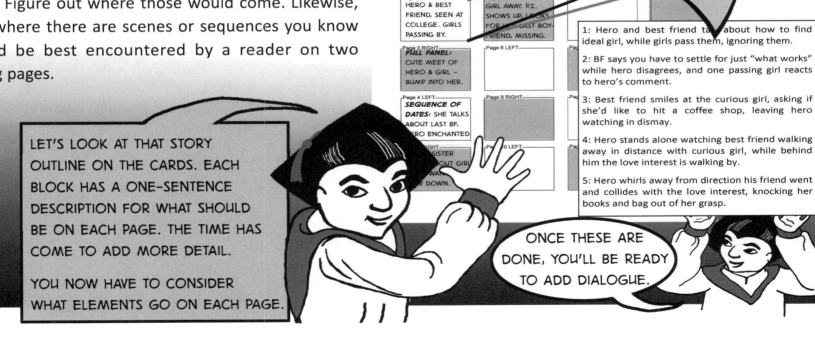

HOW MANY STORY POINTS WILL APPEAR ON THIS PAGE? THAT WILL BE THE NUMBER OF PANELS ON THIS PAGE. WRITE A ONE-SENTENCE DESCRIPTION FOR EACH PANEL.

Page 2 LEFT—
HERO & BEST FRIEND, SEEN AT COLLEGE. GIRLS PASSING BY.

Page 1 RIGHT—
ESTABLISH HERO WANTING A GIRL-FRIEND CREDITS

Page 6 LEFT—
HERO STAGES ROMANTIC MOON-LIT DATE. WINS GIRL.

Page 2 LEFT—
HERO & BEST FRIEND, SEEN AT COLLEGE. GIRLS PASSING BY.

Page 7 RIGHT—
GIRL AWAY. P.I. SHOWS UP, LOOKS FOR HER LAST BOY-FRIEND, MISSING.

Page 12 LEFT—

Page 17 RIGHT—

Page 3 RIGHT—
FULL PANEL: CUTE MEET OF HERO & GIRL – BUMP INTO HER.

Page 8 LEFT—

Page 4 LEFT—
SEQUENCE OF DATES: SHE TALKS ABOUT LAST BF, HERO ENCHANTED

Page 9 RIGHT—

RIGHT—
SISTER ABOUT GIRL WANT DOWN.

Page 10 LEFT—

1: Hero and best friend talk about how to find ideal girl, while girls pass them, ignoring them.

2: BF says you have to settle for just "what works" while hero disagrees, and one passing girl reacts to hero's comment.

3: Best friend smiles at the curious girl, asking if she'd like to hit a coffee shop, leaving hero watching in dismay.

4: Hero stands alone watching best friend walking away in distance with curious girl, while behind him the love interest is walking by.

5: Hero whirls away from direction his friend went and collides with the love interest, knocking her books and bag out of her grasp.

LET'S LOOK AT THAT STORY OUTLINE ON THE CARDS. EACH BLOCK HAS A ONE-SENTENCE DESCRIPTION FOR WHAT SHOULD BE ON EACH PAGE. THE TIME HAS COME TO ADD MORE DETAIL.

YOU NOW HAVE TO CONSIDER WHAT ELEMENTS GO ON EACH PAGE.

ONCE THESE ARE DONE, YOU'LL BE READY TO ADD DIALOGUE.

Once you have an idea about the main beats of the story that will go on a particular page, you will be ready to address the specifics of what will go in each panel.

The first question you need to ask is whether your characters need to say anything for each of those beats. Remember, because the dialogue will take up physical space in the panel, you need to decide how much what the characters have to say will meet the need of that particular panel.

But do not fall into the trap of letting the dialogue do all the work of the storytelling. This is not a stage play. Let the visuals help convey aspects of the story as well.

YOU ARE A CARELESS ONE, DANCING OTTER.

CAREFREE.

CHILDISH.

CHILD-LIKE.

PESKY.

PERSISTENT.

IT'S POSSIBLE TO HAVE A PANEL WITH BANTER, IF THE PURPOSE IS TO SHOW THE NATURE OF THE RELATIONSHIP.

REFUGE

.....

PANEL 1 SHOWS THE WOMAN ALONE.

PANEL 2: SHE REACTS TO SOMETHING.

PANEL 3 SHOWS HER HUMBLE HOME.

PANEL 4 BUILDS SUSPENSE.

PANEL 5 SHOWS OUR HERO FALLING IN THE DOOR.

In considering the "size" of the moments of your story, you need to evaluate how much visual scope you will give to them. Is the moment something that will work as one element of several on a page, or is it something that requires more space in order to convey the impact?

You may ask, "How can I be sure that the artist *gets* what I want from this page?"

This is where your interaction with your artist becomes important. You can be conversational in your script about what you want in the "look" of the story. If you are able to have actual conversations with the artist, all the better. Give the artist some leeway in making choices.

Beyond the basic panel descriptions, you can let your artist know the type of look you want.

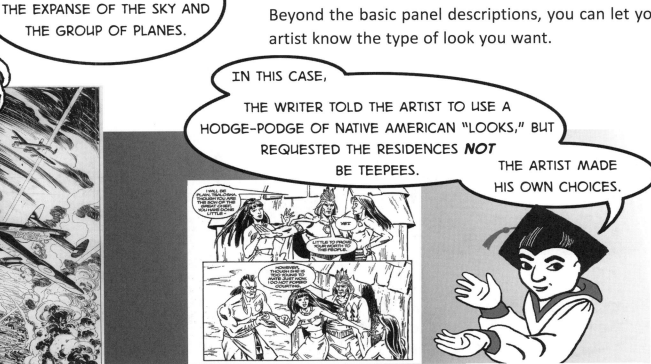

THIS SCENE REQUIRED SPACE TO CONVEY THE EXPANSE OF THE SKY AND THE GROUP OF PLANES.

IN THIS CASE, THE WRITER TOLD THE ARTIST TO USE A HODGE-PODGE OF NATIVE AMERICAN "LOOKS," BUT REQUESTED THE RESIDENCES *NOT* BE TEEPEES.

THE ARTIST MADE HIS OWN CHOICES.

But if there are specific things you want to see on the page, like a particular building or an unusual item, help the artist by providing visual references. This is especially important when you are requesting something unfamiliar to the artist.

SO, NOW YOU HAVE YOUR DIALOGUE DOWN; YOUR PANEL DESCRIPTIONS AND ANY VISUAL REFERENCES ARE AVAILABLE TO THE ART TEAM.

EVERYTHING'S READY TO GO, RIGHT?

WELL, YOU MAY DISCOVER THAT YOU WILL HAVE TO TRIM SOMETHING DOWN.

IT MIGHT BE DIALOGUE OR PAGE COUNT.

THE QUESTION THEN BECOMES *HOW* TO TRIM THINGS DOWN FURTHER?

HERE YOU SEE PHOTO REFERENCES AND THE FINAL PANEL ART.

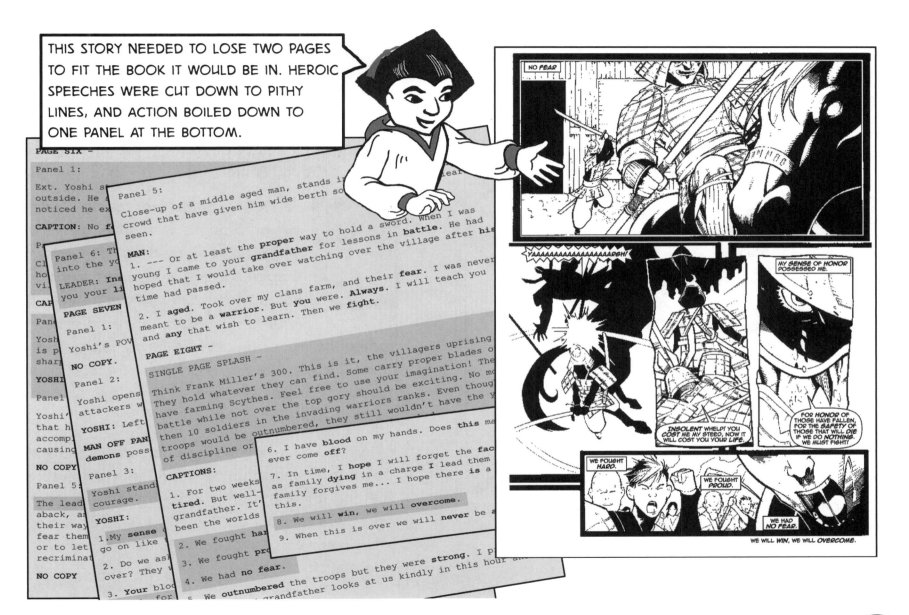

Artist and editor can find ways to shorten things, if you have an editor working with you. If you as the writer are also doing the editing job, you will have to find ways to shorten things.

ALWAYS BE PREPARED TO DO SOME EDITING DOWN AS YOU PROCEED WITH YOUR PROJECT.

The upside to all the paring down is when you finally see the finished pages. There is a special satisfaction when the writer finally gets to see what the art team has made of the script.

Danny Donovan: *The creative team did an amazing job taking what truly only lived in my head and bringing it to life. The marriage of the overall story with the drama and emotion in each panel made me remember what I loved the most about this business.* [*on "Young Ronin"*]

Sarah Beach: *For me, seeing "Tsalosha" put onto pages was exciting. The story had resided in my head for a long time. Gordon Purcell put flesh and blood on the bones of the story and made it everything I hoped it would be. He even showed me something about the nature of my main character that I had not realized, that he's a Trickster figure. It absolutely makes sense, but I wasn't conscious of it until I saw Gordon's work.*

When you have engaged your art team in the story, they put their own imaginations to work to serve it. The end result is so much more than just what the writer was thinking of. That is the wonder and power of the graphic novel (or comic book) art form. It is definitely worth the effort.

CHAPTER SIX
GIVE ME SOME CREDIT

*A*t the beginning of most graphic stories, you will find a listing of the creative team.

THE QUESTION THAT FREQUENTLY COMES UP IS "WHO IS THE CREATOR?"

What does it mean to be the creator of a graphic novel? Where does the project originate? How is credit determined?

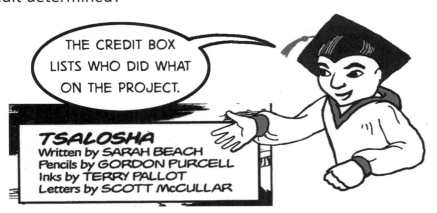

THE CREDIT BOX LISTS WHO DID WHAT ON THE PROJECT.

TSALOSHA
Written by SARAH BEACH
Pencils by GORDON PURCELL
Inks by TERRY PALLOT
Letters by SCOTT McCULLAR

Of course, if the graphic novel is to be an adaptation of a previously existing property of any sort, such matters are not so strong. Usually the creator in that case would be the writer of the original property, who would be pulling together the whole art team on a work-for-hire basis.

If the project is a fresh, original one, however, even if the idea started with the writer, the question of shared creator credit will have to be considered. For writers encountering this for the first time, they might be confused about the nature of a co-creator credit. Why would it come into play?

IN PROSE, THE WRITER ENDS UP CREATING EVERYTHING,

THE DESCRIPTIONS OF ALL THE CHARACTERS AND LOCATIONS.

NOBODY QUESTIONS THAT.

But in original graphic works, the artist frequently contributes to the definition of the characters by creating their visual look. The visual look of things can end up defining the shape of the story.

BECAUSE OF THIS MEASURE OF DUAL INPUT, GRAPHIC WORKS THAT ARE ORIGINAL ARE OFTEN CONSIDERED TO BE CO-CREATED BY THE WRITER **AND** THE ARTIST.

However, if the project is originating with the writer, there is the option of negotiating with the artist regarding credit, rights participation, and back-end compensation. It can all be discussed between the writer and artist and worked out at the beginning of the project.

If a project is going to be treated as work-for-hire, the writer (we're assuming that is who is originating the project) needs to consider a number of matters in reaching an agreement with the artist. In addition to the matter of the page rate (that is the fee per page that you agree to pay the artist for doing the work), there are matters like on-going credit for the "design" of the characters, additional possible compensation if the graphic novel ever is developed for other media (whether it is simple printed credit for the design or profit participation).

THE BIGGEST QUESTION IN THE SEARCH FOR AN ART TEAM IS WHERE TO FIND THEM.

The first hunting ground would be at conventions in the area of the Exhibit Hall called Artists Alley. This is where you will find many artists (mostly pencillers and inkers) at tables. This will give you a chance to see their work and speak with them directly.

If you find a penciller that you like, you can begin by asking that artist if there is an inker he or she works with, as well as colorists and letterers. This is using networking to find possible team members.

SEARCHING ONLINE MAY GIVE YOU A BROADER RANGE OF PROSPECTS.

THERE ARE A NUMBER OF WEBSITES THAT PROVIDE ARTISTS THE OPPORTUNITY TO HOST ONLINE PORTFOLIOS.

One of the best-known ones is the Deviant Art site (*deviantart.com*). The difficulty with this site is that most of the works posted are stand-alone pieces.

Those related to comic book art are usually pin-ups (posed pictures of characters), rather than actual sequential pages.

If an artist on the site interests you, further investigation is needed to determine how well the artist can handle the sequential storytelling. However, this site would not make it easy to find other members of your art team.

The Digital Webbing (*digitalwebbing.com*) forums are another online site for finding art teams.

By registering for the forums, you can communicate directly in the discussions. There are forums for each of the types of artists: pencillers, inkers, colorists, letterers. By participating in discussions, not just posting offers of work, you can increase your network of contacts.

Professional networking also occurs on the LinkedIn website (*linkedin.com*).

You can search for team members by their specialty. Or you can post in one of the various discussion groups devoted to comic books and graphic novels, mentioning that you are seeking an art team.

There are also sites where you can post to freelancers offering potential jobs, seeking bids from freelancers for your project. On such sites, you would need to indicate the range of pay you would be willing to offer per page.

SO,

THE TIME HAS COME TO DISCUSS THE MATTER OF "*PAGE RATES*."

In the simplest level, a page rate is the amount that you would pay an individual artist (whether the penciller, inker, colorist, or letterer) per page.

There are no set figures for page rates. You need to discuss the specifics with each individual artist you hire for the project. For pencillers, you may expect to start at around $100 per page. But even that might be moderated by other aspects of the project and the

agreements between you and the artist. When you seek to hire members of your creative team, ask each of them what their page rate is. Use that as a starting point for discussions of compensation.

Because there is such a variety of rates and possible agreements that can be reached between the project originator (the writer) and the art team, there is little point in being more explicit about the costs. No two projects are going to work out the same way.

Once the matter of compensation for the production of the graphic novel has been decided, is that the end of questions of ownership of the work?

Not entirely. Many writers new to the processes and practices of the comic book business assume that in hiring the artist to produce the pages, they are also purchasing the physical art for the work. That is not the practice of the business.

When you hire the artists, you are commissioning the creation of the art for the pages of the graphic novel. In this you are also paying for the copyrights for the finished work, meaning control of the reproduction of the work, individual pages, or the entire work. But if

your artist works on physical pages rather than originating it digitally, the original art remains the property of the artist.

(Traditionally, the penciller and the inker each get shares of the original art, if the inking is done on the physical pencils.) For the artists, the sale of original work is an important part of their regular income. If you wish to own the originals, that is a separate transaction you need to negotiate with the artists.

THE ART TEAM COMMITS LARGE CHUNKS OF THEIR LIVES TO THE COMPLETION OF THE PROJECT. THEY EARN THE COMPENSATION THEY GET PAID, AND THEY DESERVE RECOGNITION IN THE CREDIT BOX.

IN THE END, THE IMPORTANT THING TO KEEP IN MIND IS THAT EVERYONE ON THE PROJECT DESERVES RESPECT AND RECOGNITION FOR THEIR WORK.

TSALOSHA
Written by SARAH BEACH
Pencils by GORDON PURCELL
Inks by TERRY PALLOT
Letters by SCOTT McCULLAR

CHAPTER SEVEN
CHARACTER ARC

Other comics companies do publish some creator-owned properties. So it is worth your time to learn about them.

Even the traditional book publishers have gotten on the graphic novel bandwagon. Some of them even have departments that deal specifically with graphic novels.

It pays to go to the websites for the various companies and read through their submission guidelines. They are not the same for all publishers. On top of that, a publisher may change the submission guidelines at any time.

If you choose not to go to any of the established publishers, there are other options for Print-on-Demand

ONCE YOU HAVE A BOOK PULLED TOGETHER AND READY TO GO OUT, WHAT DO YOU DO?

YOU NEED TO LEARN THE PLAYERS IN THE BUSINESS AND HOW TO FIND YOUR READERS AND REVIEWERS.

Knowing the players in the business will help you get news of your book out into the world. It isn't just about finding a publisher for your book. It's about knowing what circles to network with to create "buzz" for your work. Let's start with the comic book publishers.

The top of the heap in comics is Marvel and DC Comics. Although they do not publish as many original graphic novels created by independent writers, they do publish a few.

(POD) and self-publishing. There are many options available to you.

But keep in mind that all of these options have different time frames for the process of accepting, printing, and distributing the graphic novel. You need to take that into account, if time is important to you.

Knowing the players in the business can help you get news of your book out, in terms of building word-of-mouth. It doesn't matter how you are publishing it, if you can get people "in the know" to talk about your book. Of course, the readers do need to be able to *get* the book once people start talking about it, so plan for distribution.

WHEN DEALING WITH ESTABLISHED COMIC BOOK COMPANIES, YOU NEED TO UNDERSTAND THE STRUCTURE THERE. WHO IS IT THAT DECIDES WHAT GETS PUBLISHED?

There are assistant editors, editors, senior editors, editors in chief, chief creative officers, publishers. Any one of these may have a say in whether or not the company accepts a creator-owned property for publication. You need to pay attention to who is doing what.

How do you learn who to connect with to get published?

First off, check the credits for recently published graphic novels. Somewhere in the book, even if it is initially published in hardcover as a full-on graphic novel, there will be an indication of who the editor for the book was.

Be aware that there is a lot of job fluidity in the business. The process of developing a hardcover graphic novel might take a couple of years, and the editor who is credited in the book may no longer be in that position in the company or even at that company at all by the time the book is available for sale. Even so, knowing the names of such editors is a good thing. So, once again, check the company websites. With the comic book publishers, it may be more difficult to find lists of editorial staff: some of the main comics publishers do not list staff on the publically accessible site. You

will have to spend time in the comics shops checking credits on the monthly issues in the racks. Even then, the editorial information may be three months out of date. But… that's better than addressing a communication to someone who left the company five years earlier.

The established companies have their regular readers, who may be inclined to try any original graphic novel that comes from that publishing house. But there are readers who track independent comics as well. It is possible to find your audience with a little bit of work.

Of course, if you are a screenwriter who is only thinking about having that book in hand to give the producer, you might not be concerned about matters of distribution. But you do need to remember that behind the question "Is there a book I can see?" are the money questions of "Has anyone paid to read this? Is there an audience?"

YOU MAY BE WONDERING IF YOU NEED TO GO TO AN ESTABLISHED COMPANY TO GET YOUR BOOK INTO PRINT.

NO, YOU DON'T HAVE TO.

THE MAIN QUESTION YOU NEED TO ANSWER IS

WHAT AUDIENCE ARE YOU TRYING TO REACH?

THE MATTER THEN IS:

HOW DO YOU REACH THAT AUDIENCE?

WHERE DO YOU FIND THEM?

You may wonder why you as the writer should be the one to do the work of building an audience for the work, especially if it is being put out by an established publisher. For whatever reason, these days the writer is obliged to do more work in getting the word out about a book. That means making connections in order to generate "buzz" about it.

Where then do you find the readers of comics and graphic novels, if you are not familiar with the comics world?

Comic shops, comic news websites, message board forums, reviewer sites. All these are where you can make connections with the readership.

Where do you find the local comic shops in your area?

There are websites such as *comicshoplocator.com* which provide listings for shops by zip codes. Once you are familiar with the shops local to you, you can take steps to become familiar with the owners and customers. Local shops frequently will arrange signings and events for graphic novel creators from their

area. So getting to know these owners helps you start tapping into their base of regular customers. After all, readers who have personally met a creator are frequently inclined to buy that person's works, whatever the genre. And they talk about the work to others.

ONE THING TO KEEP IN MIND ABOUT LOCAL COMIC SHOPS IS THE SCHEDULE OF DELIVERY FOR NEW BOOKS.

Usually, the week's new comics arrive at the shop on Tuesday, which means that they are in the racks on Wednesday. A lot of regular readers like to come in to pick up their issues on that day, so it's a great day for scheduling an appearance, or for just hanging out and getting to know the readership of titles like yours. Many shops have events on Wednesdays. Again, getting to know your local shops and their owners is a step in developing your networking and market reach.

The next places to find your readers are on the comic book news websites. There are several ones that regularly have posts about the latest news, and most of them have regular contributors who review new graphic novels. These are your cutting-edge reviewers, so you should become familiar with the types of things they like to read. When your book is ready for reviews, you want it to be reviewed by someone who is in tune with your work. You learn who those are by reading everyone.

Message boards and forums devoted to comics are another place to find your readers. Most of the comics news sites have forums connected to them, where there may be discussion of the posts on the news sites in addition to more general (or at least not connected to a post) discussions. The thing to be aware of on these sites is that the posters are comic book fans.

The communities tend to be very "in-group," so it may take a while for a new person to "feel at home." In addition to the news sites, many comic book writers have their own blogs and/or message boards. You can find like-minded readers at such sites as well.

Participating in Twitter feeds and the Facebook threads of professionals in the comics/graphic novel business is another way of building your audience. But you actually have to *participate* in discussions. You can't make hyping comments about your own work your only contribution to the discussions. Keep in mind the *social* aspect of "social networking." People will be interested in your work because they are interested in *you*. If you do not have an established audience, it is harder to get people interested in an "unknown" work.

ALL THIS NETWORKING IS INDEED WORK. BUT IN THE LONG RUN IT CAN BE WORTH IT. BY DOING BITS OF ALL OF THESE THINGS, YOU CAN CREATE YOUR AUDIENCE. WITH EFFORT, YOU WILL GET RESULTS THAT WILL GROW.

The one thing to watch out for in stepping into these waters is the cyber-dwellers who only live to criticize others. If you're an outsider, they may pounce. Most of them are not worth the time it would take you to compose a response. Many are wannabe creators who want to have a "name," but are not ready to do the work to gain it. Be civil and move on. Don't waste your time.

WHEN YOU ARE AN OUTSIDER TO THE COMICS AND GRAPHIC NOVEL ARENA, AND YOU DON'T KNOW ANYONE IN THE BUSINESS, **WHAT ARE YOU TO DO?**

In that case, the communities of a message board, Facebook following or Twitter feed can become even more important. Interact with a pro, get to know that person on a friendly level, treat them as a fellow human with similar interests and not a source of opportunity. And then, only after you have forged a genuine connection with the pro, ask for feedback, or a blurb, or a critique of your work. If the pro has time

(remember, they are working professionals, not hobbyists with lots of free time), they may be willing to read and compose feedback or blurbs for you.

Generally, the professionals in the comics business are friendly and congenial. They don't mind putting the word out for work they like and respect. And their reach is greater than yours will be when you are starting out. Find someone whose tastes are similar to yours and build a relationship.

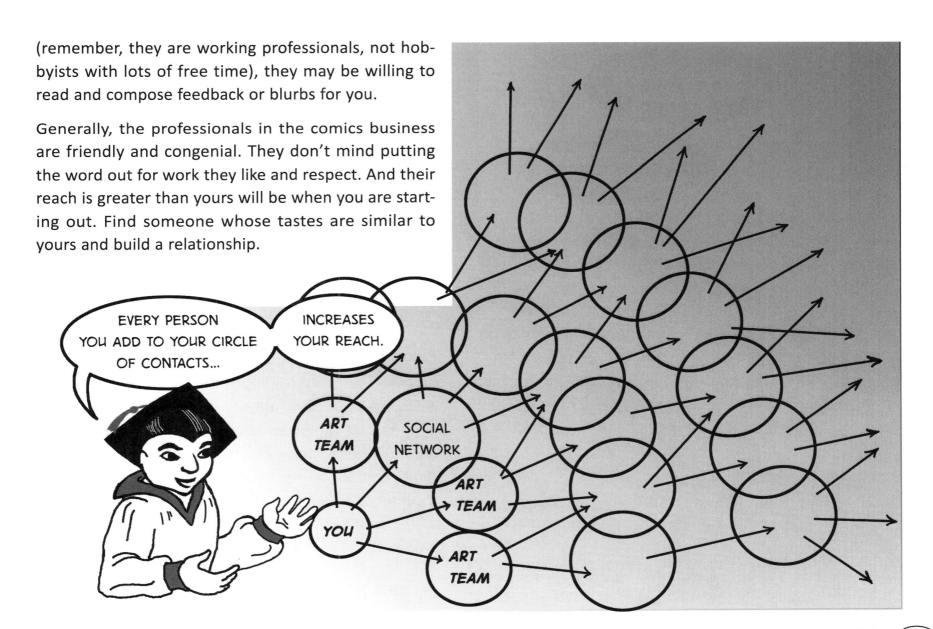

EVERY PERSON YOU ADD TO YOUR CIRCLE OF CONTACTS...

INCREASES YOUR REACH.

ART TEAM

SOCIAL NETWORK

ART TEAM

YOU

ART TEAM

Marcus Perry elaborates on his experiences of how networking can increase a creator's reach.

As part of the Razor Sharp *festival tour, I aimed for some of the larger comic book conventions that sponsored independent film festivals as well. Not only did the short's action seem to make it the right fit for this crowd, I'd also been a huge comic book fan my whole life, so the prospect of getting to screen my work for true genre-lovers was major geek wish fulfillment. Of the conventions I went after, the largest were the series sponsored by* Wizard *magazine, and the plum of them all, San Diego Comic-Con. As fate would have it, not only was* Razor Sharp *accepted into these conventions, but the short won their film festivals as well. The resulting exposure opened more doors in comics than I could have ever imagined, beginning with an article that* Wizard *published on the production of the short.*

Happily, the response to the press was positive enough that Wizard *invited my film crew and myself to tour with them for the better part of a year and host panel discussions on how to make sci-fi/action films on the cheap, as well as have a presence on their convention floors. It was through their incredible efforts that word of mouth began to spread about my little movie in the comics circles, and before long it seemed like the next step logical was actually knuckling down and creating a book.*

Again, fortune shone on me when one of the Wizard *film festival organizers, a comic book writer named Michael Dolce, offered to give* Razor Sharp *a shot in print. At the time, Mike was self-publishing a title called* Sire, *which was already a popular indie series, so when he extended to me the opportunity to do a split issue with him, I jumped at the chance. The debut of Veronica Sharpe in comics was only eight pages long and done completely in black & white by my brilliant conceptual design artist, Jeffrey Henderson, but it seemed to make the right impression. The presence of the comic in the marketplace brought an influx of traffic to* Razor Sharp's *official website, and sold well enough that further collaborations between Mike and myself seemed natural.*

While the preview issue of the comic began its circulation in print, the film side of Razor Sharp also found serious footing. The property was optioned by a producer named Giulia Prenna, a long-time development executive and VP of production at Hollywood Gang Films (300, The Departed, Se7en), who had opened her own shingle once Hollywood Gang imploded. Now under the moniker of Mind The Gap Productions, Razor Sharp would be her first project. But as Giulia and I began to shop the film for financing and distribution, it was evident the slowing economy meant an already over-cautious studio system would be even more reluctant to part with the cash we needed. And that a built-in audience would be more important than ever before.

At the same time this financing campaign was being waged, Mike Dolce and I were once again in the comics trenches. Having kicked around a handful of ideas for a new joint collaboration, we settled on another female heroine to pitch around the industry. Titled Descendant, Mike and I were fortunate to have the great Jim Valentino at Image Comics take a chance on us and publish the three-issue run, which earned me a lot of comics industry street cred in the process.

For the first time, I wasn't just a fan peering in from the outside. I had a title hit print, and in color this time. It was through this experience with Image that I was able to make significant progress legitimizing Razor Sharp in the comics arena. Knowing full well that I needed to bring Veronica Sharpe to life in print if I hoped to build the fan base necessary to push the movie over the top,

and with a sample of professional quality work that I could showcase, I was able to attract a host of talent to the new comics series. Holding tight to my brilliant Descendant artist, Mariano Navarro, I now had the formidable talents of Eisner-nominated colorist JD Smith in my corner to bring the glossy, teched-out world of Razor Sharp into fruition. And to cap it off, rockstar penciller Humberto Ramos signed on for our

cover art, giving us maximum eye-candy. But the thing I was most pleased about in regards to the Razor Sharp *comics team was their remarkable storytelling ability. I was careful to align myself with artists that were not only technically brilliant, but also understood visual storytelling like the backs of their hands. To everyone on the team, communicating Veronica Sharpe's struggle and emotions was paramount, and the world and action that surrounded her became window dressing to her characterization.*

BECAUSE AFTER ALL, NO MATTER THE MEDIUM, NO MATTER THE SIZE OF THE BUDGET...

OR HOW WIDESPREAD THE RELEASE, IF YOU **DON'T CARE** ABOUT THE CHARACTER AND THE STORY,

YOU'VE ALREADY FAILED.

AND THERE ISN'T A BUILT-IN FAN BASE IN THE WORLD THAT CAN OFFSET IT.

CHAPTER EIGHT

THE PROS, THE CONS, AND THE FANS

For someone new to the world of comic book conventions, the Exhibit Hall can seem like a confusing jungle of sensory overload objects all overwhelmed by a swarm of milling attendees.

WHAT ARE YOU TO MAKE OF IT ALL?

When you step into the doors of a comic book convention, one thing to keep in mind is that it is in essence a trade show. The publishers, game and toy businesses, film and television producers are all there to display their products and to generate advance word about their upcoming releases. So the layout of the hall is not haphazard. There are purposes behind it.

Many professionals in the comics/graphic novel field take the time to make appearances at conventions. They make a commitment to the whole duration of the Con, in fact. Again, it is about audience building. The more face-time they make with buyers at a convention, the better known they become. Unless you are Kevin Smith, making a one-panel appearance at the convention, with very little time assigned to sitting at a table signing copies of your works, you need to "work" the convention.

There are many ways to do this.

First, you can circulate through the hall, visiting booths and getting to know the editors who are there, visiting Artists Alley to meet artists (and occasionally, some writers). Be conversational.

A convention is not really the place to pitch a book, because of the high level of distraction and pre-arranged business that goes on. But it is definitely a good place to make social contact with the power brokers in the business, especially if you do not live in New York (or more frequently these days, in Los Angeles).

Be sure to have plenty of business cards to trade. They are a handy means of collecting contacts. They don't require the recipient to stop and write something down, they can be stored easily and sorted out at a later time. Be sure your contact information is on them and it is up-to-date. Don't be handing out cards with out-of-use email addresses or phone numbers. In fact, try not to have your business cards printed on glossy stock either, as those are next to impossible to annotate in any way. The card should be straightforward information. Don't be a mystery on your business card. Some cards from some artists have lovely examples of their art on them, but the name and contact information is difficult to find or read. Additionally, both sides of the card are filled with artwork and leave no white spaces for anyone to make notes.

If you know other comics/graphic novel creators, you can put together a panel to discuss your genres, being creators from a specific region or background, speaking about writing (in almost any form, in fact). You

need to contact the convention organizers months in advance in order to propose the panel. Many conventions have a deadline for suggested programming, so you would need to check their website regarding that aspect of participation.

If you are publishing your graphic novel with an established publisher, another way of getting in front of your audience is to arrange signings at the booth or table that the company has at the convention (assuming the company *does* have a booth at the event). Offer to do more than one signing, and spread them out over the duration of the convention.

Some conventions are one day, some are two, Comic-Con International ends up with a commitment of five days (since there is their Wednesday evening Preview Night before the convention officially begins). Plan on having several days given over to a specific convention.

For many creators, there may be a difficulty in getting to a convention. If you live far from a major metropolis, you will have travel considerations to plan for. Each convention varies as well in what their admission policies are, so you have to research that factor as well. And then there are your costs for housing and food during the convention. Attending a Con requires planning and preparation, especially if you are attending as a professional and/or participant.

Many conventions have discounts for attending professionals (or in some cases, even free admission). You need to check the website for the specific convention to determine what their requirements and options are. If the convention has special options for professionals, they will list the credential requirements that will gain you that special admission.

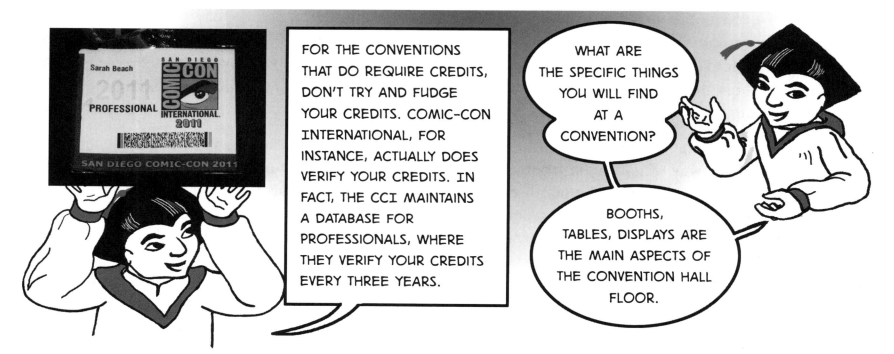

FOR THE CONVENTIONS THAT DO REQUIRE CREDITS, DON'T TRY AND FUDGE YOUR CREDITS. COMIC-CON INTERNATIONAL, FOR INSTANCE, ACTUALLY DOES VERIFY YOUR CREDITS. IN FACT, THE CCI MAINTAINS A DATABASE FOR PROFESSIONALS, WHERE THEY VERIFY YOUR CREDITS EVERY THREE YEARS.

WHAT ARE THE SPECIFIC THINGS YOU WILL FIND AT A CONVENTION?

BOOTHS, TABLES, DISPLAYS ARE THE MAIN ASPECTS OF THE CONVENTION HALL FLOOR.

There are conventions all around the country (well, all around the world, in fact). There is bound to be a Con of some sort relatively near you, no matter where you live. The conventions are also staggered throughout the year. The convention organizers try to avoid overlapping the weekend of other major shows, because they all want the same pros to appear at their own event.

Booths are large spaces taken by exhibitors. For the publishing companies, the space allows them to have displays of characters and book covers, displays of action figures and other merchandise. Additionally, the companies also make space available for signings by artists and writers.

For those who cannot handle the expense of the booth, most conventions also offer tables for those who can use *some* display space. These tables are

usually long enough for two or three people to sit at them. Many smaller, independent publishers choose this option, using smaller rack/stands to display the books they are selling. Many creators will choose this option, having copies of their works there if they are writers. Artists will have their books, original works for sale, and prints of their works.

If you opt to take a table, it means you will be manning that table for most of the convention. It would be a good idea to have an assistant to help with this. There will be times when you will be away from your table, participating on panels, for instance, but you will want your table to be manned by someone who knows your material, whom you may even delegate to handle sales for you.

Artists Alley at most conventions is a specific area that is made available mostly to artists, although some writers also take spots in that area. The artist may have half a table to present their work.

There can be a degree of sensory overload in experiencing a comic book convention. The large banners and posters for comics, toys, games, and movies make for a carnival-like atmosphere. The crowds of people milling about, waiting in line for signings or mini-events at the booths (raffle drawings for convention specials or special appearances by a celebrity), people stopping to take pictures of fans in costume, shopping for toys or t-shirts or other merchandise.

Fans (also known as your readers) respond to stories in many ways. They like the merchandice that springs from their favorite stories. And they express their appreciation actively.

COSPLAY

If you attend a comic book convention, you will see a lot of fans in costume, and you will hear the terms "**cosplay**" and "**cosplayers**." The simplest explanation is that they are fans in costume. But for cosplayers, it is more than just putting on a costume. It isn't just Halloween costuming. The significance is in the character or idea that the costuming represents. The term comes from the combination of the words "costume" and "play." Often the cosplayer will take on the attitude mannerisms and vocabulary of what is represented.

Cosplayers may be engaged in representing a general theme or trend. There have been general trends of Klingons, pirates, *Star Wars* Stormtroopers, and Steampunk citizens and adventurers. Television shows and films with distinctive looks often are popular sources of inspiration — *Doctor Who*, *Firefly*,

Battlestar Galactica, *Indiana Jones* — all have been cosplayed by fans. And of course, comic book characters as well become inspirations for cosplay.

SOME TAKE INSPIRATION FROM OTHER SOURCES.

SOME LIKE TO MASH TOGETHER INSPIRATIONS.

Cosplayers take pride in the creation and detailing of their creations. The significance of the inspiration to the cosplayer is important. But so is the craftsmanship of the costume and make-up (if any).

THIS GENTLEMAN'S DAY-JOB IS IN THE EFFECTS SIDE OF THE FILM INDUSTRY. HE TAKES GREAT PRIDE IN HIS ATTENTION TO DETAIL IN THIS COSTUME.

Cosplay is one manifestation of the fan response to works of popular culture. As a creator gets into the flow of popular culture, there are additional varieties of fans. Most fans are fine and fun, enthusiastic about the books they read, the films and shows they watch. They enjoy the brief interactions they get with creators who have inspired and entertained them.

But you should be aware of some of the few negative fringe types that may show up at a convention. But they are the minority of the attendees at any convention.

The crucial thing to remain conscious of at a convention is that those milling folks in the aisles are your audience. They are the people you want to entice into buying your stories. If you get them interested in you and your stories, they will be inclined to talk to others about them. And that is the beginning of word-of-mouth buzz.

A second point to keep in mind about conventions is that they are frequently the point where business happens, or at least begins. Producers look for potential film and television properties. Editors might be looking for new talent, particularly new artists. Readers look for new, cool things to enjoy.

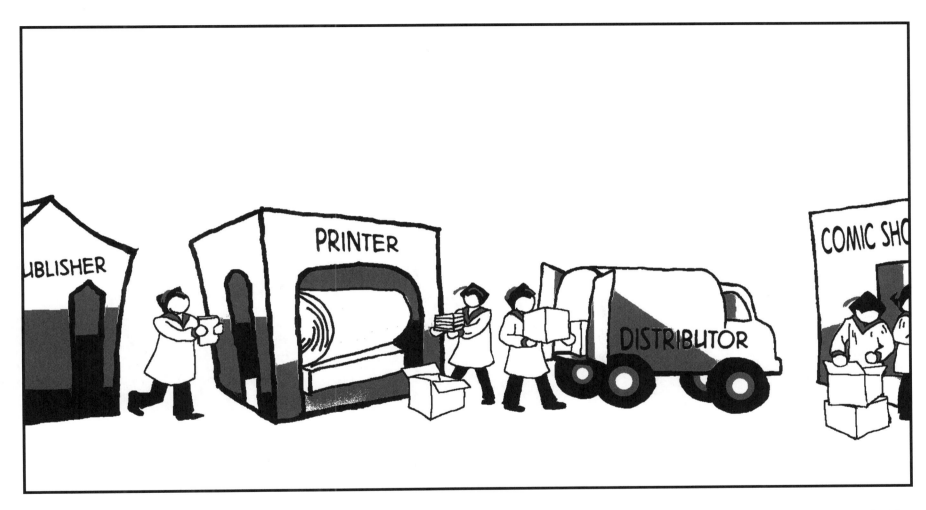

CHAPTER NINE
GETTING PHYSICAL

> THE POINT OF LEARNING ABOUT THE BASICS OF WRITING GRAPHIC NOVELS IS TO FINALLY GET THE BOOK IN HAND.

Check the website for the company you would like to approach. You will find information on how they wish to be approached and what sorts of limitations they may have on taking on new, creator-owned properties.

When you see the statement that the company "does not accept unsolicited submissions," this does not mean that they do not take on new projects.

The next major element to master is that of actually getting it into *print*. Once you are familiar with the individuals of the business, you also should become acquainted with the details of their company's submission policies and publication arrangements.

The various comic book publishing companies have different procedures regarding submissions. If your aim is to have your book published by one of them, you need to follow their submission procedures.

> THE KEY HERE IS THE WORD *"UNSOLICITED."*

That means that nobody *in* the company, in the editorial staff, has requested the material. This is why you should take the time to get to know the editors at conventions. To get an editor to request your material, you need to be known to them in some fashion.

To secure a request from an editor, you need to make a pitch or proposal to the editor. If he or she likes that, they will then request that you send the submission. That means that they "solicit" the manuscript from you. If the submission is accepted, the project will be added to the company's publishing schedule.

Some of the companies expect to see a completed project as the submission. That means you should not submit just the script for the project.

SOME COMPANIES WON'T EVEN *LOOK* AT SCRIPTS THAT ARRIVE WITHOUT ARTWORK.

Pay attention also to the conditions the publisher places on accepting a project for print. Some companies indicate that they only charge a certain fee for the publication of your project, but you will have to have all the artwork already completed (under whatever conditions you've agreed to with your art team). Companies like that tend not to request any participation in any later development of your intellectual property once it is in print.

Other companies *do* expect to be granted shares of participation in any profits of further development of the property. This is one of the trade-offs that you need to consider as you review the benefits and negatives of the option. Such a company may provide you with a large distribution, which may be worth giving them a "piece of the action."

If you wish to approach a traditional book publisher with your graphic novel, again, you need to check their website for their submission policy. Most of the book publishers expect submissions to come to them through a book agent (and quite possibly with the artwork in place).

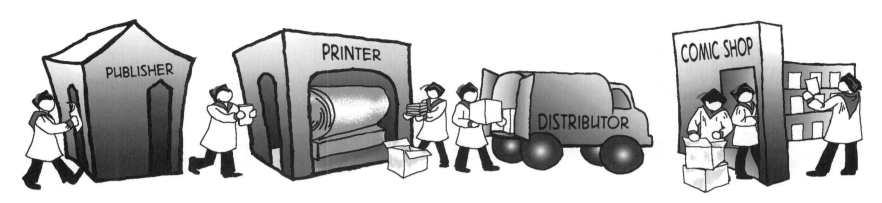

When you go with an established company (either of comic books and graphic novels exclusively or of traditional mainstream books), you need to consider the printing schedules of these houses. With a traditional book publisher, the publishing process from the time of delivery of the completed book (that means all the artwork and lettering has been finished) to the company and the actual publication of the work may be as long as a year, or as short as six months.

The biggest advantage of the traditional book publishers and established comic book companies is the element of distribution. They have built-in means to get your book out into the marketplace.

The differences between the traditional route versus that of self-publishing are things you have to consider. Are you willing to wait for the length of time it takes an established publisher to get your book out? Or would you rather get the book in hand faster and do all the work of getting it to the audience on your own?

The other option to a hard-copy book is that of digital distribution. You still have to make all the arrangements with your art team, of course. That doesn't change when you go for the digital option.

For digital distribution there are a few websites that are, in effect, cyber-bookstores for digital comics, either of the scanned-print pages or of comics designed specifically for digital distribution.

Those two websites are just the primary edge of the field. As time passes, more such sites are sure to appear.

However, many people still enjoy the experience of holding a book in hand.

WITH GRAPHIC NOVELS IN PARTICULAR, THE EXPERIENCE OF THE SEQUENTIAL ART, THE SUSPENSE OF THE PAGE TURN, ALL THESE ADD TO THE IMPACT OF THE GRAPHIC NOVEL.

The market is growing for digital distribution, and many readers are quite willing to give new, unknown works a tryout in this format. That is so primarily because digital comics tend to cost less per issue than print ones.

ComiXology is one of the prime deliverers of digital comics that are scans of the print books.

Thrillbent specializes in digital comics that are written and designed for the opportunities of effect that the digital form provides.

So, are there other options to going to the publishers of mainstream books or of comic books? Yes, there are.

You can opt to become your own publisher, and move forward in various ways.

If you choose to become your own publisher, you will need to take steps to secure your "**business identity**" in some fashion or other. You might file with your local authorities that you are "Doing Business As" (DBA), you might set up a limited liability company. These are things you need to consider if you mean to be the publisher under your own name. There are many options to be explored in this, all of which concern legal filing status and business licenses. These vary from place to place, and so are outside the scope of this work. However, with a little bit of research you will find the information you need for your own choice.

ONCE YOU'VE CHOSEN YOUR "BUSINESS IDENTITY," YOU CAN SELECT HOW YOU WANT TO HAVE YOUR BOOK PRINTED.

There are a number of printers across the country (and outside the country) that specialize in the actual printing of comic books and graphic novels. If you wish to deal with those who have had regular experience in printing sequential storytelling, a simple Internet search of "comic book" and "printers" will get you several results. You will have to make several decisions in selecting which printer will serve you best.

TO BEGIN WITH, HOW WILL YOUR BOOK BE DISTRIBUTED?

This can lead you into a whole new world of business. The distribution of comic books and graphic novels to comic book shops and to book stores for most of the Comics Industry lies in the hands of Diamond Comics Distributors.

Diamond produces a regular catalogue that lists upcoming releases of comic book titles, covering monthlies, mini-series, and graphic novels. This catalogue goes out to comic book shops across the country. Owners review the new listings and figure out if there are works that might interest their regular clientele. For instance, a shop in a town in Virginia might choose to stock a few copies of a graphic novel about a Civil War battle that took place nearby, even if the creative team on the book is unknown to the regular customers.

Additionally, many avid comic book readers also read Diamond's *Previews*, and place advance orders for titles that they find interesting.

BUT... TO BE LISTED IN THE **DIAMOND CATALOGUE**, YOU NEED TO PREPARE A SUBMISSIONS PACKET OF VERY SPECIFIC INFORMATION ABOUT YOUR BOOK.

On the website for Diamond Comics Distributors, you will find the most up-to-date information for the company's requirements for vendors. Since you will be trying to sell your book to readers, this makes you a vendor. The website has the instructions for preparing the packet needed to be considered for listing in Diamond's *Previews*. This is business. You have to plan for it.

One of the crucial elements in dealing with Diamond is getting your books to their distribution centers. This is something you need to arrange with your printer. Those printers who regularly deal with the printing of comic books are already familiar with the steps needed to ship your books to Diamond. But if you choose another option for your printing, you have to know where the books should be delivered and how that will be accomplished.

Diamond has a listing of several printers who handle comic book printing. General searches online could reveal a few more. But they are not your only option.

Another option you might consider is checking with a printing shop in your own region. You will need to know what type of binding you want for your book, of course. Most printing shops have no difficulty in doing saddle-stitched books. From their point of view, a 22- to 24-page book is not much different from a business brochure or pamphlet. If you wish to have your book finished with a prefect binding, you will need to determine whether the specific printer can accomplish that type of binding.

If you do choose to deal with a local printer, you will need to have all the necessary information for delivery to Diamond to make sure that your books arrive at the distribution center on time and with the proper number of books. If your books arrive late, it's possible that Diamond might cancel the orders that had been made. If your printer is not familiar with Diamond procedures, it's up to you to make sure the production meets each deadline and requirement.

IS DIAMOND YOUR ONLY MEANS OF DISTRIBUTION?

Not entirely. But the alternatives will require more work on your part, to make sure everything runs smoothly.

You could, of course, serve as your own distributor. This would require that you have sufficient storage to keep your inventory of your book. You would have to have the means of tracking orders and shipping out the books. That is highly labor-intensive, involving bookkeeping, packing, and shipping everything that is ordered. These activities could easily become a job in-and-of itself.

However, if you opt to use a Print-On-Demand service as your printer, you might have other choices for your distribution. Most POD services have connections to a means of distribution. Amazon's CreateSpace, for instance, will plug you directly into the Amazon offerings. Ka-Blam, a POD company that specializes in comics printing, offers distribution through IndyPlanet, through online ordering and delivery to individuals or shops.

Another option you have for handling inventory, storage, and processing orders is the service Fulfillment By Amazon. In this case, you send your inventory to an Amazon distribution center, and they handle processing of orders and keeping records of your inventory. There are small fees for the shipping and handling services, as well as a small storage fee that is based on the physical volume of your inventory, calculated on the average of the daily record of how much space your inventory takes up. This service relieves you of the matter of having a storage place for your books, as well as making sure orders are processed in a timely fashion.

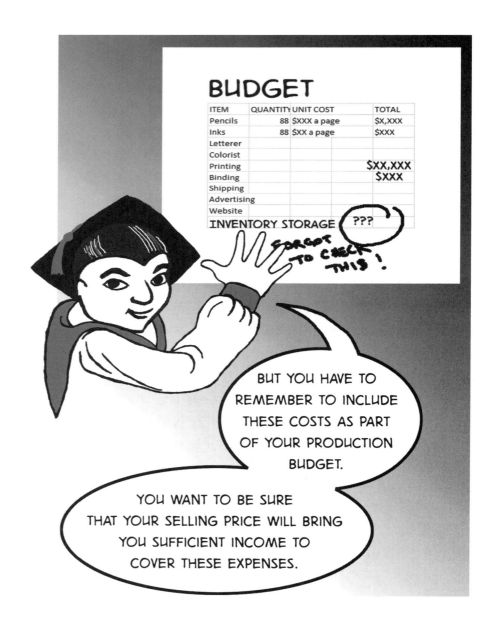

Indeed, when setting your cover price, there are aspects you should keep in mind. Your price should cover (1) your printing costs, (2) distribution and storage costs, calculated per unit, (3) production costs — what you paid the art team. Additionally, you have to remember that distributors will be paying you a discounted amount on the cover price. So you want the discounted price to still be high enough to cover your costs and give you at least a little bit of profit.

Getting your book out to the public does become quite a lot of work.

Does this all seem overwhelming in getting started? Are you wondering how to proceed with all these business matters? All you wanted to do was create a graphic novel and have people read it, right? How does an ordinary writer learn all this business side?

It is possible to hire business managers. Which means yet another expenditure for you. You can apply yourself and learn these ropes on your own. This too can be done, although it requires a lot of time and effort on your part. But at least you will have the satisfaction of knowing that you have control of your destiny.

A third option is to contact college business schools. Their students might embrace the opportunity of a short-term internship where they get to create a business plan for you. You get the benefit of their report on what needs to be done for your business to work and they get the benefit of your recommendation of their work in their academic records.

You have to make plans for how you will run your operation. Otherwise you may find yourself stuck with several boxes of books that you cannot get in front of readers.

As you can see, you do have a few options on how to handle your inventory. The important thing is to find *some* means by which to get your book into the hands of readers.

Prepare a website for your work — or works if you are planning multiple titles. You could even sell books through your website (assuming you have the appropriate sales licenses). But the website isn't just for product distribution, it is a tool to engage the audience in your material. It's your cyberspace billboard, your soapbox, your display case.

In the end, all these endeavors are directed toward one end...

YOU WANT READERS TO **BUY** YOUR BOOK AND **READ** IT.

CHAPTER TEN
TORN PAGES

MAKING PLANS FOR A PROJECT YOU ARE PASSIONATE ABOUT ALWAYS FEELS LIKE WORKING IN SUNSHINE.

YOU EXPECT IT TO GO WELL.

BUT YOU SHOULD ALSO PREPARE FOR POSSIBLE PROBLEMS.

When it comes to creating a graphic novel, once you get beyond the usual challenges of writing the story and script, there are certain aspects that cause delays or disruptions. Difficulties with the art team members might develop, printers or publishers might become unreliable, distribution plans could go awry. Or, everything in the production might go smoothly, but the first reviews of the book could stall reader response to your work. Any of these points might be daunting, but none of them need be crippling to your purpose in getting your book out into the world.

Creators tend to be like proud parents when it comes to sending their works out into the world. They want the work (whatever it might be) to be all bright and shiny and impressive.

Y ou need to consider what might go wrong in your plans to get your graphic novel into print. Knowing the possibilities ahead of time allows you to be prepared for action. Instead of having a difficulty petrify you, you will be able to move around the obstacle and continue toward your goal. The way to avoid problems is to know what could go wrong, and thus be ready to deal with problems when they show up, if they show up.

YOU WANT YOUR WORK TO CREATE THE BEST IMPRESSION POSSIBLE.

So how *do* you face down the problems that might arise?

Being prepared to deal with difficulties beforehand is a good way to start. Because you have anticipated glitches, you should be able to deal with them in a much calmer fashion. There are few things more impressive than someone who handles problems with an assured manner, instead of wailing and whining and stalling out by playing "blame games."

Let's start with publisher and printer problems. One of the first things to do is check out the reputation of the companies you are considering dealing with. This is where being engaged in the creative communities of the comic book world can help you. It is very easy to find people who have dealt with most of your possible printers and publishers. All you need do is ask what the experience was like for others. You may learn things that speak to your situation. One company may be fast, but their books fall apart easily. Another may be slower, but they use high-quality materials and the books look good. But by checking around for information like this, you can prioritize your options. So if a serious problem develops along the way that causes

you to change vendors, you have a good idea of what will suit you.

Even with the best of intentions, things can go wrong with art teams. First off, life happens, and you should expect that. Ideally, the "life happening" events won't seriously affect your work and schedule, but they could. If you are fair with the members of your team, you help maintain stability for all concerned.

Illness and accidents can come up. Household disruptions can cut into an artist's work day. There are very few artists who intentionally fall behind on a paying job. By staying in communication with your team, you will be in a better standing with them if a difficulty comes up. Simple courtesy and concern mixed with adaptability will gain you a good reputation in the art community, and incline the team members toward desiring to work with you on other projects.

If one of the team members has to bow out, ask if they can recommend someone to take over for them. An artist might know someone who can finish your book without drastically changing the nature of the work that has been finished. Many artists can work in different styles, and can thus step into a previously established project. There might be some differences in styles, but if the two mesh well enough, the changeover between the artists need not pull you to a full stop.

There may be occasions, however, where no amount of attempted communication can bring you news of what is happening with the artist. Some people just turn out to be flakes. This is one very good reason for being careful about how you arrange for payment of work.

Some artists may request a commencement fee, for some money to be paid up-front. There may be pragmatic reasons for this. Artists usually live very modest lifestyles, and they may need the up-front money in order to restock their working supplies. Comic boards (the Bristol card-stock that has blue-lined guides for pages and panels) don't come cheaply. Pencils and pens may need to be restocked. Of course, they are not obliged to tell you why they request a portion to be paid up-front. From their end of things, a willingness on your part to make a commencement payment tells them that *you* are making a serious commitment to the project and are not likely to disappear without paying when they deliver the work.

So be prepared to pay a certain amount at commencement. After that point, however, your agreement should specify that final payments are made on delivery of the work.

AND WHEN YOU SAY "THE CHECK IS IN THE MAIL," IT HAD BETTER **BE** IN THE MAIL.

BETTER YET, IF THEY CAN RECEIVE IT THAT WAY, MAKE YOUR PAYMENT BY AN ONLINE SERVICE.

THIS HELPS ELIMINATE MAIL AND BANK DEPOSIT DELAYS.

If the difficulties between you and the art team concern matters other than payment, again, your participation in the comics community can help sort things out. As with publishing and printing companies, checking out the reputation of artists is a sensible thing to do.

When it comes to criticisms broadcast on the Internet, you need to know which noises are worth addressing and which can be passed over. If you attempt to engage every possible negative word that might be spoken, you will have no time to devote to useful promotion of your work or for starting your next project.

A bad review could cause the beginning of bad word of mouth about your book. So you have to pay attention to what is regarded as the negative. If someone doesn't like your point of view or stance on any particular issue, you don't need to enter into battle: let the story speak for itself.

Never launch an attack at a reviewer, for the clash of personalities can take on a life of its own. The saying is "Nothing dies on the Internet." Everything that is said in a public forum can be found years later and come back to haunt you. Readers take the personal biases

of the reviewer into account. In the comics/graphic novel arena, most of the reviewers are "known quantities" and the readers are aware of their preferences and biases.

What you should be concerned about is if someone launches a bad review of your work before it has even surfaced in the marketplace. Be very careful of what types of advance viewings and readings you give to people. Assume the possibility of misunderstanding could be high, and act accordingly. Don't show a spectacular page of artwork because you are so pleased with the art in and of itself when the content of the image might need some context to explain what is really going on.

The important thing is to trust in the quality of the work you and your team are doing. Good work has a way of enduring beyond passing controversies. Don't let yourself get over-anxious about things going "wrong."

When it comes to the legal paperwork for your project, take the time to make sure you get it all right and tight. You do not want to find yourself left out in the cold at some point in the future because you overlooked the real legal meaning of something that was included in the contract language.

KNOW WHAT RIGHTS YOU DO HAVE, WHICH RIGHTS YOU MIGHT BE SHARING WITH YOUR ARTIST...

AND WHICH RIGHTS YOU WANT TO HOLD ON TO.

Because of the potential for broadening your market share as well as the opportunities for merchandise licensing, if you have your eyes set on a possible film deal you really should know your rights. You could easily sign away *all* your rights to the story and the characters if you do not pay attention to the wording of the contract.

This is why you really should run your contracts past a lawyer. But not just any lawyer. Find one who specializes in entertainment and intellectual property law.

Don't make the mistake of thinking these matters aren't really important to you. You have put a lot of work into creating your story. You should therefore gain as much benefit from your work as is possible.

In many cases, for an original work (that is a graphic novel that starts out as a graphic novel, rather than being an adaptation of the story from another medium or form), you as the writer may be sharing your rights with your artist as a co-creator. In that case, you need to be clear about the terms of any future development of the story and characters. Who can do what with them? How does the co-creator share in the benefits of future developments?

Lest you think these are small matters, you should take a little bit of time to look into the history of the rights to the property of the most famous superhero in comics, Superman. Or into the contentions between the Jack Kirby Estate and Marvel Comics regarding characters Kirby developed for Marvel. The issues of copyrights, trademarks, and intellectual properties

in general should concern *anyone* who becomes engaged in creating material intended for the Pop Culture market.

Which brings us to a major question that can confuse many people.

People tend to mash copyright and trademark together, thinking they are the same thing or that the conditions of one are the same as the conditions of the other. But they are *not* the same thing.

COPYRIGHT

"**Copyright**," properly speaking, is a noun not a verb. You do not "Copyright your work," you "Secure a copyright *for* your work." But, you know someone will come along and say, "I copyrighted my work."

What any creator needs to realize is that, in American law at least, you gain a copyright to your work the moment you put it into a "fixed form." That means, as soon as you write out your work on paper, or on a computer, it is "fixed." You can reproduce it in some fashion: that is, you can *copy* it, so that others might

WHAT ARE COPYRIGHTS AND TRADEMARKS?

AND HOW ARE THEY DIFFERENT?

TM

®

©

see, read, or otherwise experience your creation. Because you are the creator, you have certain *rights* regarding the material. Hence the term: "copyright."

You *always* have a copyright on your work, once you finally put it into a fixed form. Having the copyright is *not* dependent upon your registering the work with the government or otherwise securing "proof of authorship."

"Boy meets girl, and they suddenly get zapped to the moon."

That is an *idea*. There is not yet sufficient detail to the concept for it to be called a unique creative work. Any twelve people could take this idea and generate a dozen different stories from it, each of which would then have its own copyright.

Many novice writers worry about having their ideas stolen. But ideas are a dime a dozen. The value of an idea is generated in how the individual creator *executes* the idea.

HOWEVER, YOU CANNOT HAVE A COPYRIGHT ON *AN IDEA.*

SO REMEMBER, YOU *ALREADY* HAVE A COPYRIGHT ON YOUR WORK...

AS SOON AS YOU GET IT INTO A *FIXED* FORM.

DON'T GET PARANOID ABOUT *NOT* HAVING A COPYRIGHT ON YOUR WORK.

YOU *DO* HAVE ONE.

You also cannot lose your copyrights through inattention, "dis-use," or any other indirect means. The only way you can lose any part of your copyright is by the *action* of signing them over or selling them.

Registering your works with the government secures you certain privileges should you need to defend your copyright. By registering your works, should you be obliged to go to court to defend your copyright, when you win the case you get certain benefits, such as having your legal fees paid by the other side. Registering your work does also assist in determining priority, if matters of "who did it first" are part of the question.

For more detailed information about copyright, what it is, what it does, and how to register your work with the government, go to the government's own website. At *copyright.gov*, you will find all the basic information you need, plus you can register your work online. The instructions are readily available. If you have more questions, certainly seek legal advice.

What you should pay serious attention to are the exclusive rights that attach to the holding of a copyright. These are the elements that are important to the exploitation of an intellectual property.

The top of the list is the right to produce copies or reproductions of your work and to sell those copies (even electronic copies). When pirates copy your works and sell them, they are infringing on your right to do this yourself; they're making money off your work and you are not getting a penny from it. You want to protect this right if you want to hold onto your share of the market.

You can import or export your work, you can perform or display your work publicly, you can transmit or display it by radio or video. You can do all these things because you *own* the right to do these things with your work.

But the right you really want to keep an eye on is the right to create derivative works of your original piece.

That means secondary works that adapt your intellectual property to new forms.

This is one of the advantages of turning your stories, especially your screenplays, into a graphic novel for its first appearance in the marketplace. You establish your work in a specific fixed form, and thus control the possibilities of secondary development. Usually when screenwriters sell their film scripts, the purchasing entity will also buy the rights to make derivative works. That allows the purchaser to turn the story into additional forms such as sequel stories, games of all sorts, other types of books.

An extreme example of careful shepherding of rights from the creation of a property is that of J.K. Rowling and the *Harry Potter* books. She took her time in selling the rights of the books for the making of films. She kept a degree of control over anything that was derived from the books or films. This wisdom has made her a very rich woman.

As you can see, it's a good idea to pay attention to the possibilities that spring from the rights you *own* because of your creation of an intellectual property.

TRADEMARKS

A "**trademark**" serves a different purpose than copyright. It is not the same thing at all. A trademark is a distinctive design, sign, or expression that identifies a thing as something different from other things. Its purpose is to establish an identity in the marketplace, to signify that a service or product comes from a particular source and not some other source.

Company logos are trademarks, for they identify the products as coming from the particular company. Brand name titles on books, particularly when they are given a distinctive visual style, frequently do the same thing (such as "brand name" travel books like *Fodor's* or *Rough Guides*).

In the realm of comic books, the character designs for many long-standing characters have been trademarked. Superman, or Batman, or Marvel's Thor, each has a distinctive, iconographic design so that anyone

passing a rack of comic books knows at a glance what they are and where they came from.

The savvy creator should be aware of these matters as well as staying on top of their copyright issues. If you manage to create a character that is so distinctive visually and in personality that people recognize it after only brief exposure, you may have something that is worth handling as a trademark.

Remember, the trademark is not an automatic privilege. Use of a trademark indicates business intentions, so don't consider it a casual matter.

Unlike registering a copyright, registering a trademark is a more involved and expensive process. Be sure you know what you want out of the process before you begin it, because it is a thing to be *used* and not simply a thing to *have.*

This is why you should know the difference between the "Registered Trademark" symbol and the "TM" you often see on logos and brand names and such. The "R" means that you have gone through the legal process of registering your logo with the government, filing all the papers, and paying all the fees. The "TM" means that you are indeed using the logo (or character or whatever) *as* a trademark or brand, and you have the intention of registering it. It is a way of signifying actual business *use* prior to registering the emblem.

If you have a specially designed logo for the title of your work, especially if you are intending it to be a possible franchise, that logo has the potential to be a trademark. In making a decision about having a trademark, think visually: What do you want as your "brand"?

And as always, check with an intellectual property lawyer for legal advice on these matters. Do your research, certainly, but check with an attorney.

BEFORE YOU SIGN AWAY THOSE KEY DERIVATIVE RIGHTS TO YOUR STORY...

TAKE A GOOD LOOK INTO ALL THE POSSIBILITIES.

Does your story have the potential to be the source for a franchise? Perhaps you've created special characters that the audience will want to revisit a lot. Perhaps you've created a place or a situation that people will want to come back to again and again. Are you ready to give the exploitation of your material over into the hands of other people — just "take the money and run"? Or are you going to want to take part in that additional development? Give these matters some thought, and then make sure your contract reflects your desire. People usually *are* willing to negotiate on such points. You won't know if you don't ask.

But never give up any of your rights without careful consideration. Intellectual properties do have value, often very high value. You should keep that in mind.

Because IP (intellectual property) can have such value, there are plenty of unscrupulous people out there who will try to make off with your rights, either by tricking you into signing them away or by simply stealing the material and paying you nothing for it. Never treat the piracy and theft of an intellectual property lightly. "It happens all the time" does not make it right or even necessary. Protecting your property rights and trademarks is *always* worth the effort. Respect yourself and the work you have done in creating the property. Don't treat it like dirt, and you will benefit from taking care of it.

So...

Pay attention to your contracts. Sometimes contracts are sloppily written out of ignorance. Sometimes poor terms (from your point of view) get written in. Be aware that even after you have gone through several bouts of negotiation over terms, some operators will still try and pull a fast one in the actual contract. *Always* double-check the actual contract before you

sign it. Have your legal representative check it over for dicey language. Stay on top of the rights you are selling or licensing; only part with the ones you wish to part with and keep all others for yourself.

Keeping a "piece of the action" is simply good business sense, when you can make it work. But don't be so stubborn that you shut yourself out of a deal. Keep your eyes on the potential for transmedia development of your story material, for some new technology for storytelling might come along. You want to be able to take advantage of the Next New Thing.

DON'T BECOME THE VICTIM OF A CONTRACT HIT.

INSTEAD, BE THE BENEFICIARY OF A HIT CONTRACT.

CHAPTER TWELVE
IT'S A MISPRINT

After reading all this information about finding art teams, how to get the book into print, marketing, and all the legal concerns, you may be wondering if it is really worth the effort to try and put your story into graphic novel form. It always comes back to "How much do you want to tell this story?"

ERIC SHANOWER LOVES THE STORY OF THE TROJAN WAR.

HE WANTED TO TELL IT AS ONE BIG STORY.

He pulled together all the various elements from all the different stories that were spun off that war. Blending story lines from many different sources was work. And then the characters had a lot to say. Would it be possible to make this work as a graphic novel (or as it turns out, a *series* of graphic novels)? Because he is passionate about the story, he makes it work.

If you are questioning how well your story will work in this format, focus on what makes you passionate about the tale. Perhaps you have a story that has a lot of talking or internal thoughts as part of the narration, something that doesn't seem to have a lot of visual potency to it. Can this be made to work as a graphic novel?

Yes.

You do need to think about the potential for visuals in your story. Look deeper into it than you had previously. What are the visual elements that can be exploited to help you convey the deeper meanings of your story? How can you make the visuals help tell the story?

For instance: apparently static imagery need not be entirely static, *and* it does not always need to repeat what you put into the narration, for the visuals can easily contrast with the text in the graphic novel form.

IN FILM, A PASSAGE OF TIME SEQUENCE LIKE THIS WOULD TAKE A FEW MOMENTS, MINUTES WHERE "NOTHING HAPPENS" EXCEPT THE PASSAGE OF TIME.

IN COMICS, BECAUSE OF THE WAY OUR VISION WORKS, WE "READ" THE PASSAGE OF TIME IN THE SEQUENCE, BUT WE *SEE* IT ON THE PAGE AT ONCE.

OUR BRAINS RECOGNIZE THE IMAGERY *AS* "PASSAGE OF TIME" WITHOUT *TAKING UP TIME* IN THE READING.

ONE WAY TO ENLIVEN A STATIC VISUAL LOCATION IS TO SHOW THE PASSAGE OF TIME --

EITHER BY TIME OF DAY AND CHANGES OF LIGHT AND SHADOW...

OR IN TIME OF YEAR WITH THE CHANGES OF SEASONS.

It is easier to compress time in the graphic format.

Another thing that the graphic form can do effectively is the presentation of contrasting imagery and narration. Consider the same images we were just looking at: what happens when you couple them with a drastically different narration?

IN FILM, VOICE OVER NARRATION IS OFTEN CONSIDERED UNSUITABLE. BUT IN GRAPHIC STORYTELLING, CAPTION NARRATION, WHICH IS LIKE A VOICE OVER, CAN BE A VERY EFFECTIVE TOOL.

Static visual imagery can achieve things in a graphic work that would not be successful in film. But the key to making them work lies in touching the readers emotionally in some way.

One of the main things that graphic storytelling can do that film cannot is reveal the internal thoughts of

THE DOCTORS GAVE ME ONLY WEEKS TO LIVE.

AS THE DAYS STRETCHED, I SAW HOPE DYING IN MY LOVED ONES.

LEAVES FELL AWAY. FRIENDS FELL AWAY.

BUT IN THE DARK, I FELT A BRIGHT HOPE GROW.

a character. It is a by-word in screenwriting that if we will not be able to *see* something on the screen, it should not go into the script — and thoughts cannot be seen. But in a graphic novel, thoughts *can* be seen, either in narrative captions or in thought balloons.

Graphic novels are well suited for visualizing the internal aspects of a story. This is something that comics can do better than film. You just have to think of engaging ways of visualizing those story aspects.

Reconsidering your storytelling options is one of the principal elements of adapting a tale from one medium to another. You have to give some thought to the aspects of the new medium that make it different from the original one. The change in presentation format may change certain centers of attention in the story. It may make one character become more prominent.

It is, perhaps, your last final evaluation as to whether you want to go ahead with this adaptation to the graphic novel form. Can you make your story work in this new (to you) medium?

The question behind all this is this: Is the form of the story more important to you as a storyteller, or is the story the most important thing?

It's not a frivolous question. Some bits of our creativity will insist on one particular form and not another. There is nothing wrong with that. But most of the time, we are moved to tell a *story*, and it doesn't matter so much whether we tell it in prose, in a

graphic novel, on film, or in verse. Hey, even interpretive dance might be called for.

But in the end, usually, it is the story itself that moves us, that drives us to communication.

And that is what makes adapting a story from one form to another possible. It is the story that is important.

AND WHEN IT COMES TO CREATING A GRAPHIC NOVEL,

THE OBJECT IS GETTING TO THE POINT OF HAVING THE BOOK IN HAND.

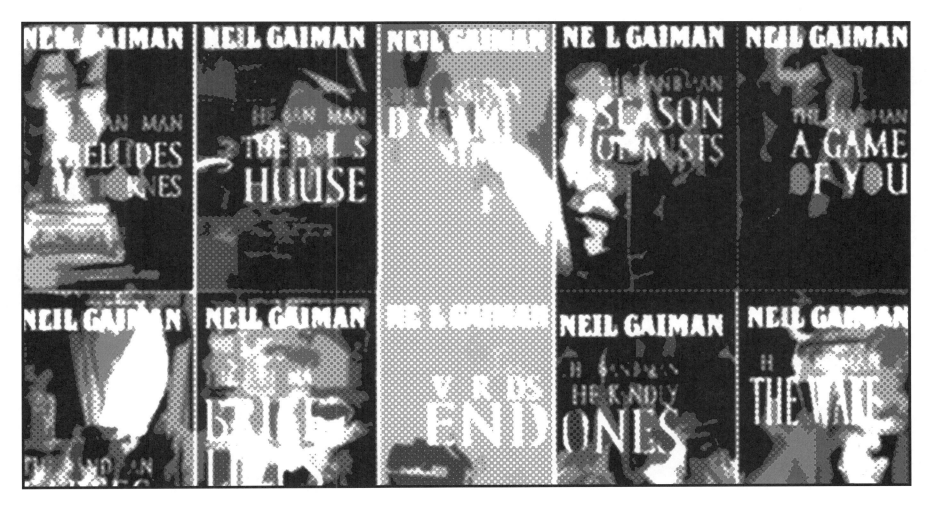

CHAPTER THIRTEEN
SHELF LIFE

There are advantages to getting your story into a graphic novel form. A longer shelf life is one of them.

> GETTING YOUR STORY INTO A GRAPHIC NOVEL FORM CAN HELP KEEP IT IN FRONT OF A CONSTANTLY GROWING AUDIENCE.

AGE OF BRONZE BETRAYAL PART ONE Shanower

AGE OF BRONZE SACRIFICE Shanower

BRONZE A THOUSAND SHIPS Shanower

Of course, if your story has started its life in prose and in a book form, it is already doing that. But a graphic novel adaptation still expands the possibilities.

For one thing, in brick-and-mortar bookstores, the graphic novels are usually placed in a location that is easily accessible to younger readers. For another, when libraries order graphic novels, they tend to be shelved together in a conspicuous spot, again accessible to a broad readership. While bookstores might drop a title if it does not sell well or quickly, a library will keep a book on the shelf as long as possible.

If you as a writer are trying to keep your potential audience alive and growing, you want your individual works to have as much longevity as possible. In order to do that you need to do what you can to keep the book in print. In order to convince a publisher to do *that*, you need to demonstrate an ongoing readership. When readers see that a title continues to be available, their curiosity is aroused.

> WHY WORRY ABOUT THE LONG-TERM LIFE OF YOUR BOOK?

The advantage in staying in front of audiences is that the longevity of the work invites development of the material in other media. If you have your eyes on the possibilities of video games, card games, or even film and television development, the durability of your work becomes a definite asset.

Of course, getting into bookstores and libraries takes us back to the issues of distribution. If your book is published through the traditional channels of either standard books or comic books, it will be listed in the industry catalogues that go out to bookstores and libraries. If, on the other hand, you are going the independent route, you are the one who has to do the work of informing stores and libraries that your book is available.

Lest you think that it is impossible to stay in print, there are a number of titles that show that it can be done. It is worth noting that the one element that has secured these titles their longevity is good storytelling. Of course, everyone wants to believe that their own tale has that kind of impact on readers. But keep it in mind as an inspiration to pull out all the stops as you work on your material.

Here are some titles that have endured in the graphic novel form.

Astro City was originally published in August 1995 as a series. Written by Kurt Busiek, co-created and illustrated by Brent Anderson, with painted covers by Alex Ross, the title gives readers a look into the lives of the citizens of Astro City, a metropolis that has attracted many super-powered beings, both good and bad.

Without collected volumes, the series might have had a brief time in the sun before disappearing from publication. Creator-owned titles are hard to sustain in the market because they must make their way, usually, without the strong arm of a publishing house's publicity machine behind them. However, *Astro City* holds its own in the racks of graphic novels at local comic shops. The ongoing growth of the audience

has allowed the creators to return to the series after breaks, putting out new issues of the tales.

A more famous example of the longevity of a graphic novel version of a limited comic book series is that of *Watchmen*, written by Alan Moore, with art by Dave Gibbons, and colors by John Higgins.

Initially published in 1987, the title attracted the attention of readers and has *never gone out of print*. By the time the film version was released in 2009, the title had gone through 22 printings. Because the collected volumes were marketed as a graphic novel, the book got into traditional bookstores and libraries. It became the cutting edge of this practice. From the vantage point of those institutions, one could see how its audience grew over the years. Sheer persistence in the marketplace helped increase its visibility.

Alan Moore also had another title which gained a long lifespan in the graphic novel form, *V for Vendetta*. Illustrated by David Lloyd, the title began its life in 1982 as a strip in a periodical anthology of comics. Originally published in black & white, it was one of the most popular strips in the anthology. When the anthology folded (with the story still incomplete), in 1988 the tale was republished by DC Comics, in color. The storyline was finished and the issues were collected as a trade paperback. Its durability on the shelves led to the film adaptation in 2005.

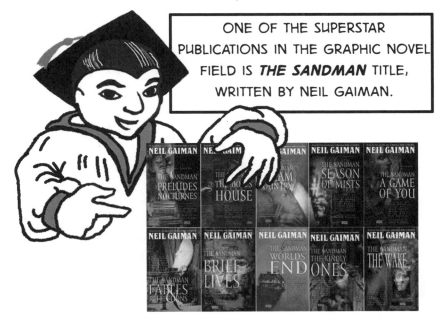

ONE OF THE SUPERSTAR PUBLICATIONS IN THE GRAPHIC NOVEL FIELD IS **THE SANDMAN** TITLE, WRITTEN BY NEIL GAIMAN.

Gaiman was given a free hand to make something of a character called Sandman, and his creation of Dream and the others of the Endless was the result. The series attracted much attention. When the issues were collected and printed as graphic novels, the attention expanded exponentially. It became one of the few graphic novels to ever be on the *New York Times* bestseller list. Although its initial sales were not strong by comics standards, it drew in a new audience of mainstream literature readers, nearly half of which were female.

In the graphic novel form, the series has continued to draw new readers year after year. All ten volumes have been kept in print since their original publication. The impact of the series is such that in October 2013, a 25th Anniversary Exhibit of the art of *The Sandman* opened at the Cartoon Art Museum in San Francisco.

Of course, even longevity in print can have its problems, as some graphic novel creators are discovering. Some titles can fall out of print not because they have ceased to sell, but rather because the negatives for the pages have been lost. A printer needs clean, clear negatives in order to do a new print run of a title.

Scans of previous printings do not provide that degree of clarity.

Artist and writer Colleen Doran has overseen the process of a fresh restoration of her epic space-opera series, *A Distant Soil*.

She began publication of the title in the mid-1990s, but had to halt work on it in 2006. She had successfully managed to keep reader interest in her sprawling tale engaged through a long hiatus in publication. As she finally became able to wrap up the story in 2013, she also began work toward the publication of a fully

restored edition of the earlier volumes. She discovered that the original printers had lost many of the negatives of the early work. A painstaking process of tracking down the original artwork (many pages of which had been sold years before), careful restoration of grey tone-work, and much attention to detail in correcting minor errors has resulted in new editions.

Doran grew her audience during the hiatus by making the work available for free on her own website, while urging her online readers to purchase the hardcopy volumes as well. This careful shepherding of the property has greatly extended the shelf life of the title, to the point of allowing the creator the opportunity to finish the epic tale.

The near-disaster of the loss of her negatives served as a warning call to many other creators. Several discovered that the negatives for their works had been lost by printers along the way, through accidents or negligence. It became another reminder that creators need to stay business-minded in overseeing the preservation of their materials.

IF YOU WANT TO MAKE MORE OF YOUR STORIES, YOUR INTELLECTUAL PROPERTIES, YOU HAVE TO KEEP YOUR AUDIENCE ENGAGED.

How do you maintain that connection over the long term?

You keep the engagement going by keeping the books in front of the audience. Engaging with readers in various ways, both online and in person at local comic shops and conventions can begin the process. Interacting with readers on your own website or in the social media of Facebook or Twitter also helps raise the profile of your works. Finding ways to market the

material also can increase awareness of your book: prints of artwork from your graphic novel, t-shirts of the characters, various accessories that feature art. There are now online services that will create merchandise using imagery you provide. These can be tapped to assist in marketing your works.

What you want is to achieve the longevity of these well-known titles, growing the reading audience and developing new avenues of exploiting your intellectual property.

AS ALWAYS, YOU **WILL** HAVE TO DO SOME WORK TO KEEP YOUR AUDIENCE ALIVE.

IT MAY BE THE POPULAR TREND TO **READ** ABOUT ZOMBIES,

BUT READERS WHO **ARE** ZOMBIES ARE NOT LIKELY TO SPREAD MUCH WORD-OF-MOUTH.

HOLLYWOOD COMES CALLING

Thus, Hollywood tends to look toward those arenas where intellectual properties have been tested and may even have an already established audience. If your book has gained an audience of any sort, it can attract attention of the producers who want to make films. A built-in audience for a property can be a good selling point, if you want to make a film deal for your story. A published graphic novel, even if its audience is small, can be considered "pre-tested material."

MANY MOVIE PROPERTIES HAVE BEEN DEVELOPED FROM STORIES THAT STARTED OUT IN GRAPHIC SEQUENTIAL STORYTELLING.

MAYBE YOU DON'T TRUST HOLLYWOOD TO HANDLE YOUR BOOK PROPERLY.

The worldwide market for cinematic entertainment requires a constant flow of material. Where is Hollywood to find such a consistent supply? In spite of the number of writers who live in Hollywood, the percentage of material that is ready to be put before an audience remains low.

Nobody is claiming that every film adaptation of a graphic novel will suit the "devoted" reader. Often, the original creators will be dissatisfied with the film adaptation. But a less than satisfactory film doesn't change the printed version (assuming that you have read the contract carefully and have avoided signing

away *all* your rights to the previously published material and any future materials).

Even so, it's a good reminder to pay attention to what is in any contract offered you from any Hollywood business. What rights and permissions are you giving over to them?

The ideal situation for you is that you have participation in the profits of further development of the intellectual property beyond the making of a film adaptation.

REMEMBER, WHATEVER COMES OF THE FILM ADAPTATION OF YOUR BOOK,

THE BOOK ITSELF STILL REMAINS AS IT WAS.

IT DOESN'T CHANGE.

EVEN THEN, YOU HAVE TO UNDERSTAND WHAT THE TERMS YOU AGREE TO ACTUALLY MEAN.

When author Gary Wolf signed the deal contract for the rights to his novel *Who Censored Roger Rabbit?*, among the returns agreed to was 5% of gross receipts that Disney derived from exploiting the characters. However, because the contract did not spell out a definition of "gross receipts" it led to a dispute between Wolf and the studio. Knowing the significance of terminology is very important, and the reason why it is wise to consult a lawyer who is familiar with intellectual property rights. The ancillary development of the intellectual property could lead to many surprising things.

Admittedly, for some writers the possibility of a film sale of the graphic novel is just extra gravy in the process. But for others, it is the desired goal and purpose behind choosing the graphic novel medium for the first appearance of the story. As long as you are telling a good story that engages the audience, your motives are your own business.

Still, once it is out of your hands and is being developed by Hollywood, the question will come up as to how you will deal with changes to the material that get made for the film version. The first thing to get in your head is that the film is not going to be like the original. Switching to a different medium of storytelling cannot help but change aspects of the story.

Whatever happens to the film adaptation, you are getting the advantage of the contract, plus additional exposure for the book. There will, after all, be an inevitable degree of cross-pollination of new people into the readership of the book.

ENJOY THE RIDE.

AND REMEMBER THAT THE FILM AND BOOK CAN CONTINUE TO EXIST SIDE BY SIDE.

CHAPTER FIFTEEN
TELL ME A STORY

After plowing through all this information about the mechanics of being published and other business concerns, you may be re-evaluating the prospects of making a graphic novel.

WHY ARE YOU DOING THIS AGAIN?

Writers are motivated by their love of storytelling. That means putting their stories in front of an audience of some sort. From a handful of close friends to large circles of readers who know nothing of the author personally, writers long for people to enjoy their stories.

Once upon a time, the options for storytelling were very simple.

WE TOLD STORIES DIRECTLY TO OUR AUDIENCE SITTING FACE-TO-FACE AROUND CAMPFIRES.

But these days there are many possible media to use to convey our stories. There are still the traditional modes of oral storytelling, which now includes audio books. Standard book publishing works side-by-side with graphic novels. And now we also have digital

means that can deliver material as well. The savvy storyteller learns as much about each medium as possible. You want your story to reach as many people as possible. So take advantage of each advance in technology.

Some people only see the work involved in learning to tell a story in a medium they are not used to. But if they take the time to think of all the things a particular medium can do, they should become inspired by the possibilities. Whatever medium you are most used to, whether it is novel writing or writing scripts for screenplays or stage plays, adapting your story to another medium will make you look at your tale from a different angle.

Other storytellers are concerned about the amount of time it takes to adapt a story, especially adapting it to the script of a graphic novel. And of course, once the script for the graphic novel is done, there is the time that the artist requires to do the pages. Making a graphic novel is not a fast process. But then, neither is making a film, for that requires the cooperation of actors, cameramen, crews, and post production specialists.

If you find yourself being discouraged by the process of getting the story out, remember that you have something to say. And also keep in mind the inspiration that can come from interaction with the audience. Their response to the story can energize you to do it all over again with the next project.

To keep going, find reliable readers who will support you in the development process. Getting feedback along the way can be very helpful, so long as it doesn't make you start second-guessing your story too much. Trust whatever it was about the story that made you passionate about it.

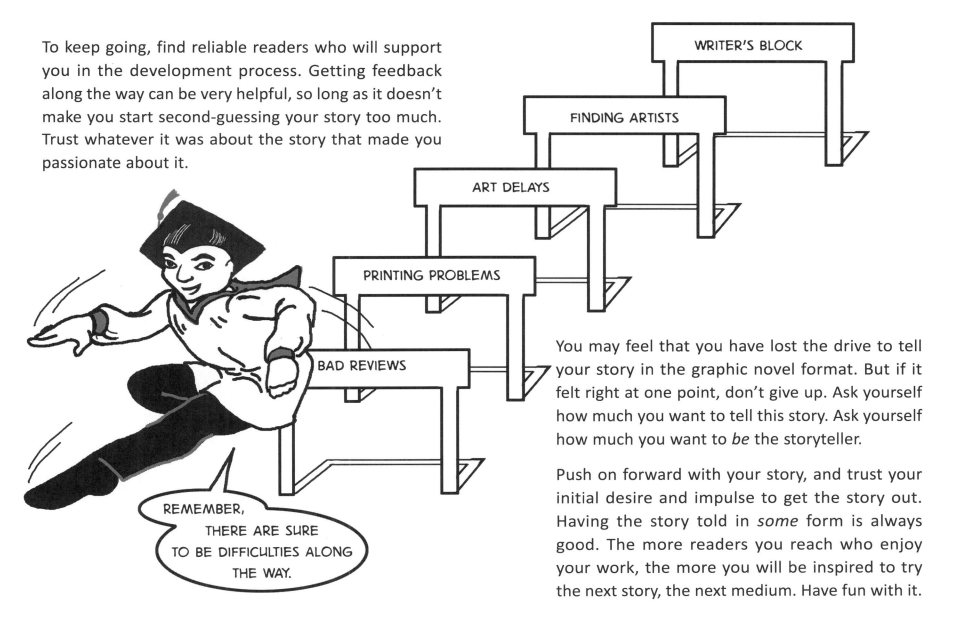

WRITER'S BLOCK

FINDING ARTISTS

ART DELAYS

PRINTING PROBLEMS

BAD REVIEWS

REMEMBER, THERE ARE SURE TO BE DIFFICULTIES ALONG THE WAY.

You may feel that you have lost the drive to tell your story in the graphic novel format. But if it felt right at one point, don't give up. Ask yourself how much you want to tell this story. Ask yourself how much you want to *be* the storyteller.

Push on forward with your story, and trust your initial desire and impulse to get the story out. Having the story told in *some* form is always good. The more readers you reach who enjoy your work, the more you will be inspired to try the next story, the next medium. Have fun with it.

CHAPTER SIXTEEN
END CREDITS

There's been a lot of information scattered throughout this book on where to find things. Those resources are gathered here for quick reference.

ARTIST TEAM

Deviant Art

deviantart.com

Under the category "Cartoons & Comics" you can find artists who are geared toward sequential artwork. There are subcategories of "Digital Media" and "Traditional Media," where you can explore the different looks.

Diamond Comics Distribution

http://vendor.diamondcomics.com/public/

Under "Production Assistance" in the left sidebar navigation menu, you will be taken to a resource page with links to lists of well-established professional colorists, letterers, and printers who regularly serve comic book production.

Digital Webbing

digitalwebbing.com

The forums at this website are a good place for getting a broader sense of what artists may be doing and are interested in doing. There are separate boards for artists, inkers, colorists, letterers, and even writers.

LinkedIn

linkedin.com

Many artists maintain profiles on LinkedIn. You can search for them under a general "comic book artist" search or by the specific position you are trying to fill.

COMIC BOOK PUBLISHERS

The following listing is not intended to be comprehensive, nor does it reflect how many of these publishers welcome creator-owned projects. There are many smaller houses not listed here which may be interested in publishing your work. You will have to do research. In all cases, remember to check the Submission Guidelines for each company, since each has their own requirements. Also remember that "unsolicited" does not mean that they absolutely will not consider your proposal: it means they have to ask to see the work in question.

Archaia Entertainment — *archaia.com*
A smaller house, but they do publish several creator owned titles.

Aspen Comics — *aspencomics.com*
Another smaller house, with a distinctive visual style.

Boom! Studios — *boom-studios.com*
Founded in 2005, they publish a mix of licensed properties and original titles.

Dark Horse Comics — *darkhorse.com*
Founded in 1986, they have published many independent, original titles.

DC Comics — *dccomics.com*
One of the leaders in the comic book industry, they do not publish many original graphic novels of independent material. Their greater focus is on their large catalogue of intellectual properties. However, they do occasionally publish original material.

IDW Publishing — *idwpublishing.com*
IDW began publishing comics in 2000 and by 2013 was considered by Diamond Comic Distributors to be the #4 comic book publishing company in America. They publish a mix of licensed titles and creator-originated works.

Image Comics — *imagecomics.com*
Since 1992, Image has been the home for many creator-owned properties. They specialize in publishing material that is neither owned nor licensed by a particular company.

Marvel Comics — *marvel.com*
As with DC Comics, Marvel focuses on their own catalogue. In the past, the Icon imprint has published creator-owned properties of established comic book creators.

Oni Press — *onipress.com*
Established in 1997, Oni Press was created to publish independent works. Respected for the eclectic range of titles, the company is home to many successful creator-owned properties.

Top Cow — *topcow.com*
Although the company focuses mostly on their own properties and franchises, they have been known to publish independent, creator-generated projects.

TRADITIONAL BOOK PUBLISHERS

In recent years there have been a number of mergers among the traditional book publishing houses. That is likely to continue. If you are looking for publication with one of these companies, review the catalogues of their various imprints before having your agent contact them (and assume that you will need a book agent for these publishers). Know which imprint would be best suited for your work, which imprints now publish a number of graphic novels.

Simon & Schuster — *simonandschuster.com*
They do publish a number of graphic novels each year.

Random House — *randomhouse.com*
The largest general interest book publisher in the world, Random House has absorbed a number of other publishing imprints, such as Doubleday and Knopf. They do have imprints that publish graphic novels.

Penguin — *penguin.com*
Penguin had absorbed a number of companies along the way of its growth, notably G.P. Putnam and Sons.

NOTE: In July 2013, Penguin and Random House merged. However, at the time of this writing, both houses still maintain their individual websites and imprints.

HarperCollins — *harpercollins.com*
HarperCollins has also acquired a number of imprints that may be well known to readers.

The Hachette Book Group — *hachettebookgroup.com*
In 2006, the Hachette group acquired the Time Warner Book Group. Among their imprints is Yen Press, which publishes graphic novels and manga. Little, Brown & Co. is one of their other well-known imprints.

Georg von Holtzbrinck Publishing Group — *holtzbrinck.com*
This publishing conglomerate owns several well-known American imprints: Farrar, Straus & Giroux; Henry Holt & Co.; St. Martin's Press; Macmillan Publishers.

It cannot be repeated enough: the publishing world is in flux, with companies merging and changing. Do your research in order to target those publishers that seem best suited for your material.

SELF-PUBLISHING AND PRINT-ON-DEMAND

When it comes to self-publishing, where you choose to be your own publisher, you can have your printing done locally, or with printers that specialize in serving the comic book industry. For the latter, consult Diamond Comics Distributors' site. If you don't choose that route, contact your local printers and find out if they can handle the specifications you require for your graphic novel, particularly in regard to the quality of the paper used and whether or not they can handle full color printing. Also remember to discuss the type of binding they can provide: you do *not* want to have your graphic novel delivered to you with a spiral binding. You want either perfect binding or saddle-stitch.

There are many Print-On-Demand companies that can be found online. You will have to investigate them for yourself. There are, however, three of note that have reasonably good reputations.

Ka-Blam Digital Printing — *ka-blam.com*
Ka-Blam primarily focuses on printing comics and graphic novels. They offer both saddle-stitch and perfect binding. However for the wrap-around card stock covers of a perfect binding on your book, your work needs to be at least 80 pages long in order for anything to be printed on the spine of the book. They print both black & white and color interiors. They provide distribution through Indy Planet as well as direct mailing to those purchasing books.

Lulu — *lulu.com*
This Print-On-Demand service handles many print formats. Various sizes and bindings (including hardcover and case-wrapped bindings) are offered, as well as options for black & white or color interiors. Distribution can be provided through Amazon and Barnes & Noble, as well as any other arrangement you choose to make.

CreateSpace — *createspace.com*
Amazon's Print-On-Demand service will automatically plug you into Amazon's listings. They offer both black & white and color interior printing, in a wide variety of trim sizes. Covers, however, are limited to card stock with perfect binding (meaning they are trade paperback books).

DIGITAL PUBLISHING

The simplest version of digital publishing would be posting pdf or jpeg files on your own website. That would however limit your distribution to whatever traffic your website already has and how much more you can drum up by advertising and working through social media.

However, the arena of digital publishing of comics is a fast-growing aspect of the business. Already, Marvel and DC Comics offer various aspects of their entire library of works through digital channels.

ComiXology — *comixology.com*
The site is quickly become the premiere home for digital comic distribution. Both Marvel and DC Comics use it as an avenue for digital releases. They also provide digital exposure for independent comics and graphic novels.

Thrillbent — *thrillbent.com*
The site is geared toward more experimental explorations of graphic storytelling in the digital medium. Although in fall 2013, the site runners are not accepting new submissions, they anticipate doing so in the future. Keep an eye on it for possible options.

COMIC BOOK NEWS WEBSITES

Ain't It Cool News — *aintitcool.com*
The precursor of other comic book news sites, Ain't It Cool early on branched out into coverage of all popular culture manifestations. Its reputation was made on collecting insider rumors from Hollywood. Early comic book nerds on the Internet built the site's reputation. They still keep tabs on what is happening with comic books and graphic novels.

Bleeding Cool — *bleedingcool.com*
This site is overseen by Rich Johnston, who built his reputation as a rumor hunter in the comics industry (originally at the Comic Book Resources website). The site covers cutting-edge news in the business, as well as posting some reviews of comics and graphic novels. Johnston and his bloggers occasionally interview creators about upcoming releases. There is an active discussion board community attached to it.

Comic Book Resources — *comicbookresources.com*
CBR, as it is often referred to, provides straightforward coverage of comics and graphic novels. In addition to general blogs of opinion, the site also reviews new titles. The CBR forums host publisher

and character specific boards as well as some creator message board communities.

ICv2 — *icv2.com*

The website specializes in covering the business of Pop Culture. They stick to hard-nosed business figures on sales. They regularly track sales figures on comics and graphic novels.

Newsarama — *newsarama.com*

This site also uses the reviews, blogs, and discussion forums format. In addition to comic book and graphic novel coverage, they keep tabs on film & television and gaming news.

THE CONVENTION CIRCUIT

Comic book conventions can be found throughout the country (well, actually around the world). The following listing is not comprehensive, but rather deals with some of the better known ones. Size is not necessarily a factor. The listing is arranged geographically. Please pay attention to the "usual" dates. Most of the conventions occur at approximately the same time of year each year.

There are some sites, such as *conventionscene.com*, which track the specific schedules of conventions.

This list is for conventions held in the United States. They are listed by state, then city they are held in, and then their title, so that it is easier for you to find the conventions nearest to you.

Arizona, Phoenix — **Phoenix Comicon**
A growing convention, since 2010 held late May or early June.

California, Los Angeles — **Comikaze Expo**
Begun in 2011, but growing, it is held at the Los Angeles Convention Center in the fall

California, San Diego — **San Diego Comic-Con International**
The largest of the comic book conventions, with attendance now topping 120,000, the four-day (or five, if you count the Wednesday registration and Preview Night opening) covers all of pop culture with huge panel presentations and a massive exhibit hall.

California, San Francisco — **APE** (Alternative Press Exposition)
A smaller convention, APE focuses on self-publishers, independent and alternative publishers and cartoonists. Since 2008, it is held in the fall, usually October.

California, San Francisco (or Anaheim) — **WonderCon**
Usually held late March or early April, located in San Francisco for most of its history. In 2012 and 2013 due to renovations and location conflicts at San Francisco's Moscone Center, it was held at the Anaheim Convention Center (where attendance increased).

Colorado, Denver — **Denver Comic Con**
Begun in 2012, it's a well-received convention, held in June.

Florida, Orland — **MegaCon**
A large multi-genre convention, held usually in late February or early March

Georgia, Atlanta — **Dragon Con**
A popular convention with a heavy fantasy and science fiction bent, usually held late August/early September.

Illinois, Chicago — **C2E2** (Chicago Comic & Entertainment Exposition)
First held in 2010, mostly in April, but once in March, it quickly became a popular stop on the convention circuit.

Illinois, Chicago (suburban) — **Wizard World Chicago**
The flagship of Wizard World conventions, it's held in the summer, since 2009 in August (after the San Diego convention). One of the larger conventions in the circuit.

Maryland, Baltimore — **Baltimore Comic-Con**
A smaller but well-respected convention, it's the home of the annual Harvey Awards.

Maryland, Bethesda — **Small Press Expo**
Held in the fall, its title is self-explanatory.

Michigan, Dearborn — **Detroit Fanfare**
Held in the fall, usually October

Michigan, Novi — **Motor City Comic Con**
Held in May.

New York, New York — **Big Apple Comic Con**
This convention has an erratic history, and an erratic naming, most recently also known as Wizard World New York City Experience. Its dates have shifted around the calendar, so one should pay attention to any news of this convention.

New York, New York — **MoCCA Festival**
Created by the Museum of Comic and Cartoon Art in 2002, it's a small convention focusing on independent comics. Up through 2009, it was held in June, since then, in April.

New York, New York — **New York Comic Con**
Begun in 2006, this convention has been growing in popularity, and since 2010 it's been held in mid-October.

North Carolina, Charlotte — **Heroes Convention**
A small but respected convention, usually held in June.

Ohio, Columbus — **Mid-Ohio Con**
Originally held in late November, the dates have moved forward in the fall. Since 2012 it's held in late September, at which time the name was officially changed to Wizard World Ohio Comic Con (though colloquially it's still referred to as Mid-Ohio Con).

Ohio, Columbus — **Small Press and Alternative Comics Expo**
A small convention held in the spring, in April since 2012.

Pennsylvania, Monroeville — **Pittsburgh Comicon**
Most of its history, it has been held in April, but in 2009 and 2013 it was held in September.

Pennsylvania, Williamsport — **Wildcat Comic Con**
A new (as of 2012), small convention held at a college.

Tennessee, Memphis — **Memphis Comic and Fantasy Convention**
Begun in 2010, held in the fall.

Texas, Austin — **STAPLE!**
An independent media exposition, held in March.

Texas, Houston — **Comicpalooza**
First held in 2008, Comicpalooza is held at the George R. Brown Convention Center, it occurs in late May.

Texas, Irving — **Dallas Comic Con**
First held in 2002, it has expanded from a two-day convention to a three-day convention. The dates have been variable, so keep an eye on news for its schedule.

Utah, Salt Lake City — Salt Lake Comic Con
First held in September 2013, its successful attendance numbers (about 80,000) promise future occurrences.

Washington, Seattle — Emerald City Comicon
First held in 2003, in 2011 it expanded to a three-day show and is growing in popularity.

Prepare for the necessity of promoting your work. You should consider establishing a website, either for your whole body of work (like an online portfolio), or for your specific graphic novel. Additionally, you should consider maintaining a Facebook presence and a Twitter feed. Being accessible (to a certain degree) is one way of boosting your audience.

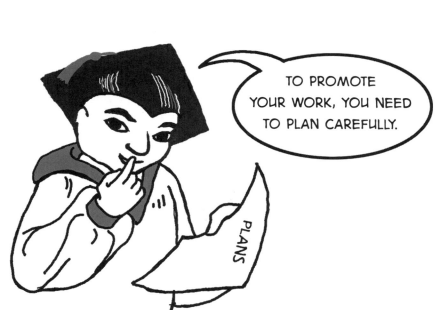

It depends on what sort of "wrong" is happening.

First and foremost, make sure you have access to an intellectual properties lawyer. The contract issues

involving IP can be very specialized, so you need someone who can recognize tricky wording. Remember that the lawyers for "the other side" are not there to be *your* friend.

For copyright issues, begin your research at the government's own site. It is clearly laid out and has all necessary forms and documents. There are also organizations that work to protect creators' copyrights. Stay on top of your rights. The information is readily available.

Remember to plan to make appearances in support of your graphic novel. If you believe you have stage fright in front of people, just remember your passion for your story.

CHAPTER SEVENTEEN
WHAT ABOUT A SEQUEL?

WHAT ABOUT ADAPTING YOUR GRAPHIC NOVEL AS A FILM SCRIPT?

ESPECIALLY IF THAT IS NOT WHERE IT STARTED OUT?

I f Hollywood does come calling, and your graphic novel is picked up as a film project, you have to go through the adapting process all over again.

First off, remember that the original writer of a previously published intellectual property is often given the privilege of writing at least the *first* draft of the screenplay. If you have not learned the ins-and-outs of screenwriting before this time, you would have to begin right away.

There are several good books on screenwriting. Ideally, if your story structure works in the graphic novel, it should work fairly well in a screenplay. But the fact remains that sometimes it is not so.

There are many things that can be done in graphic novels that cannot be done on film (for various reasons). Even though advances in special effects generation have made wonderful things possible in film, a graphic novel can still take the reader to quite fantastical locations and introduce them entirely strange and alien creatures that film doesn't easily visualize.

When it comes to adapting your graphic novel to the film formats, the first things you need to be conscious of are the expected limitations of the film production. The budget expectations of the production will have an effect on the choices you can make. In the beginning of the process, you need to discover what those limitations are likely to be. Your choices will be shaped by them.

The process of adapting the graphic novel will involve making changes yet again. As before, keep in mind the core of the story that originally inspired you.

The main considerations you need to be mindful of are: keeping the size of the cast within reasonable boundaries, and the number of locations within budgetary concerns.

There is another element to keep in mind as you prepare your adaptation of the graphic novel to the medium of film—

DOES THE PRODUCTION COMPANY HAVE A DESIRE TO DEVELOP THE MATERIAL AS A FRANCHISE?

Whether the company is thinking of additional films or a television series, if they want the possibility of answering "What happens next?" — you will have to leave some things unresolved in the story. The

characters will need to have some place to go, some problem to resolve, some question to answer.

YOU NEED TO ASK YOURSELF SOME TOUGH QUESTIONS

WHEN YOU RESHAPE YOUR STORY FOR THE SCREENPLAY VERSION.

First: What is the minimum number of characters you will need?

Start with the three characters you absolutely must have: your protagonist, antagonist, and the love interest (assuming it's that type of a story — if it's not, then the third person will be the hero's mentor or sidekick). As you proceed, you may add other characters, but start with the three that you *have* to have.

Second: What are the key scenes of action and motion in the story?

Do not include scenes that are *just* action and motion; make sure that what happens in all that motion is something that moves the plot forward. We need to learn something about the hero's goals because of the actions, or about the nature of some character's personality, or a piece of information that moves the story forward.

THIS MAY SOUND OBVIOUS, AND YOU MAY PROTEST THAT **EVERYTHING** IN THE GRAPHIC NOVEL ALREADY DOES THESE THINGS.

Real time spans are crucial in film storytelling. You do not have a lot of time available to you in which to unfold the story. Every minute counts on the screen. Translating the story from the graphic page into those moving frames on the silver screen requires that you rethink how the scenes play out.

Third: Which locations are absolutely necessary, and which are just there for spectacle?

Many times a writer will set a scene in a location because they like the location, or they want to indicate the scope of a situation. But if you included in the graphic novel that conversation in the gardens of the Taj Mahal between the hero and his love interest just because they are globe-hopping romantics, re-evaluate it. Find out if the film budget can afford the location shot. If not, can they afford to shoot the scene in front of a green screen and use file footage of the Taj? (As long as it doesn't look tacky, of course.) And if that is not workable, ask yourself why the characters need to be in India in the first place. Maybe all the story really needs is to be set in some lovely garden park somewhere.

As you re-evaluate your story for these pragmatic production concerns, don't lose hold of the heart of your story. You may feel that you are losing control of your story, this tale that you have put a lot of time and effort into shaping.

You've already told the story in one form. You have that satisfaction, and the book has its own life. Adapting the story into a screenplay won't change that. It's just one more shape your tale can take. You aren't going to lose anything in the process of adapting it into film.

CREDITS AND PERMISSIONS

ART

Cartoon of Marcus Perry by Sarah Beach.

Professor Exposition created by Sarah Beach.

"Noir Femme Fatale" by Jim MacQuarrie.

Font: Digital Strip 2.0, copyright Nate Piekos for BlamBot.

COMICS AND GRAPHIC NOVELS

Covers for *Age of Bronze*, by Eric Shanower, used by permission.

Descendant covers, used by permission.

Iron Ghost, written by Chuck Dixon, art by Sergio Cariello, pages and script used by permission.

Panel art from *Joe Frankenstein*, written by Chuck Dixon, art by Graham Nolan; inks by Graham Nolan, Drew Geraci, and Tone Rodriguez, used by permission.

"Refuge," by Stan Sakai, from *Usagi Yojimbo Sketchbook 9*, used by permission.

Cover of *Tori Amos Comic Book Tattoo* used by permission of Image Comics.

"Tsalosha," written by Sarah Beach, pencils by Gordon Purcell, inks by Terry Pallot; originally published in *Shooting Stars Comics Anthology #1*.

"Young Ronin," script by Danny Donovan, pencils by Jon Malin, inks by Dash Martin, script and page used by permission; originally published in *The Unscrewed Anthology*.

PHOTOS

ALL PHOTOGRAPHS BY SARAH BEACH UNLESS OTHERWISE NOTED

Marcus Perry and *Razor Sharp* art used by permission.

"Aspen Booth, Phoenix Comic Con 2013" photo by Victoria Morris, used by permission.

"Bayeux Tapestry," photo from *fotolia.com*, used by license.

"Cave painting," photo from *fotolia.com*, used by license.

"CJ Hurtt," photo, used by permission.

"Danny Donovan," photo, used by permission.

FAIR USE IMAGES

Company logos, used under Fair Use Practices (DC Comics, Marvel, Aspen, Boom! Studios, Top Cow, Image, Dark Horse, IDW, Archaia, Oni; Diamond Comics Distributors, Deviant Art, Digital Webbing, LinkedIn, ComiXology, Thrillbent).

Cover and poster art used for instructional purposes only:

Astro City

Iron Man

Road to Perdition

The Sandman

V for Vendetta

Watchmen

Whiteout

Who Framed Roger Rabbit?

Panels from Wally Wood's 22 Panels That Always Work.

Photo from *The Wizard of Oz*, copyright by Metro-Goldwyn-Mayer.

Information on the "Who Framed Roger Rabbit?" case: "Who Killed Roger Rabbit's Share of Gross Receipts?" by Neil J. Rosini and Michael I. Rudell, posted June 27, 2008, on the website of Franklin, Weinrib, Rudell & Vassallo, PC. (*http://fwrv.com/articles/100788—who-killed-roger-rabbit-s-share-of-gross-receipts.html*).

ACKNOWLEDGMENTS

I want to thank everyone who ever let me bend their ear about this project over the last four years. You always seemed interested — I hope you really were.

There are a few people who I need to thank by name, however.

I have to thank Derrick Warfel, since it was my discussions with him about adapting a screenplay as a graphic novel that began this process. Erik Burnham and Jim MacQuarrie have been handy advisors along the way. Barbara Randall Kesel also gave me an excellent pointer when I needed it. Deep thanks to Chuck Dixon for giving me open permission to use *Iron Ghost* as examples. To all my friends and colleagues who supplied responses for the text (I've already listed you once, so I won't repeat that), thank you. I'm especially grateful to Victoria Morris and Julie Lombard, who gave me lots of encouraging support during the final stages of finishing this book. My thanks to the energetic Paul S. Levine, for doing his job and being a friend.

And lastly but by no means least, to my editor Ken Lee, who had the bright idea of using landscape layout and making the book "more graphic." Without him, Professor Exposition would never have come into existence — and I've grown very fond of the fellow.

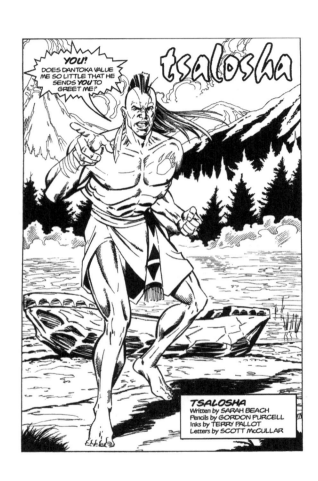

TSALOSHA
Written by SARAH BEACH
Pencils by GORDON PURCELL
Inks by TERRY PALLOT
Letters by SCOTT McCULLAR

ABOUT THE AUTHOR

Sarah Beach is a multi-faceted writer living in Los Angeles. She's a former researcher for the quiz show *Jeopardy!* She has published a book on mythic motifs for writers, *The Scribbler's Guide to the Land of Myth*, which has been recommended by Blake Snyder and Linda Seger. She has edited independent comic book anthologies, and had her own short stories published in them. She is also an artist. She's a member of both the Greater Los Angeles Writers Society and the Comic Art Professional Society. Her website is *scribblerworks.us*.

SAVE THE CAT!®
THE LAST BOOK ON SCREENWRITING YOU'LL EVER NEED!

BLAKE SNYDER

BEST SELLER

He's made millions of dollars selling screenplays to Hollywood and now screenwriter Blake Snyder tells all. "Save the Cat!®" is just one of Snyder's many ironclad rules for making your ideas more marketable and your script more satisfying — and saleable, including:

· The four elements of every winning logline.
· The seven immutable laws of screenplay physics.
· The 10 genres and why they're important to your movie.
· Why your Hero must serve your idea.
· Mastering the Beats.
· Mastering the Board to create the Perfect Beast.
· How to get back on track with ironclad and proven rules for script repair.

This ultimate insider's guide reveals the secrets that none dare admit, told by a show biz veteran who's proven that you can sell your script if you can save the cat.

"Imagine what would happen in a town where more writers approached screenwriting the way Blake suggests? My weekend read would dramatically improve, both in sellable/producible content and in discovering new writers who understand the craft of storytelling and can be hired on assignment for ideas we already have in house."
 – From the Foreword by Sheila Hanahan Taylor, Vice President, Development at Zide/Perry Entertainment, whose films include *American Pie, Cats and Dogs, Final Destination*

"One of the most comprehensive and insightful how-to's out there. Save the Cat!® *is a must-read for both the novice and the professional screenwriter."*
 – Todd Black, Producer, *The Pursuit of Happyness, The Weather Man, S.W.A.T, Alex and Emma, Antwone Fisher*

"Want to know how to be a successful writer in Hollywood? The answers are here. Blake Snyder has written an insider's book that's informative — and funny, too."
 – David Hoberman, Producer, *The Shaggy Dog* (2005), *Raising Helen, Walking Tall, Bringing Down the House, Monk* (TV)

BLAKE SNYDER, besides selling million-dollar scripts to both Disney and Spielberg, was one of Hollywood's most successful spec screenwriters. Blake's vision continues on *www.blakesnyder.com*.

$19.95 | 216 PAGES | ORDER NUMBER 34RLS | ISBN: 9781932907001

24 HOURS | 1.800.833.5738 | WWW.MWP.COM

THE WRITER'S JOURNEY
3RD EDITION
MYTHIC STRUCTURE FOR WRITERS

CHRISTOPHER VOGLER

BEST SELLER
OVER 180,000 COPIES SOLD!

See why this book has become an international best-seller and a true classic. *The Writer's Journey* explores the powerful relationship between mythology and storytelling in a clear, concise style that's made it required reading for movie executives, screenwriters, playwrights, scholars, and fans of pop culture all over the world.

Both fiction and nonfiction writers will discover a set of useful myth-inspired storytelling paradigms (i.e., "The Hero's Journey") and step-by-step guidelines to plot and character development. Based on the work of Joseph Campbell, *The Writer's Journey* is a must for all writers interested in further developing their craft.

The updated and revised third edition provides new insights and observations from Vogler's ongoing work on mythology's influence on stories, movies, and man himself.

CHRISTOPHER VOGLER, is a veteran story consultant for major Hollywood film companies and a respected teacher of filmmakers and writers around the globe. He has influenced the stories of movies from *The Lion King* to *Fight Club* to *The Thin Red Line* and most recently wrote the first installment of *Ravenskull*, a Japanese-style manga or graphic novel. He is the executive producer of the feature film *P. S. Your Cat is Dead* and writer of the animated feature *Jester Till*.

$26.95
448 PAGES
ORDER # 76RLS | ISBN: 9781932907360

THE SCRIPT-SELLING GAME 2ND EDITION
A HOLLYWOOD INSIDER'S LOOK AT GETTING YOUR SCRIPT SOLD AND PRODUCED

KATHIE FONG YONEDA

The Script-Selling Game is about what they never taught you in film school. This is a look at screenwriting from the other side of the desk — from a buyer who wants to give writers the guidance and advice that will help them to not only elevate their craft but to also provide them with the down-in-the-trenches information of what is expected of them in the script selling marketplace.

It's like having a mentor in the business who answers your questions and provides you with not only valuable information, but real-life examples on how to maneuver your way through the Hollywood labyrinth. While the first edition focused mostly on film and television movies, the second edition includes a new chapter on animation and another on utilizing the Internet to market yourself and find new opportunities, plus an expansive section on submitting for television and cable.

"Kathie Fong Yoneda knows the business of show from every angle and she generously shares her truly comprehensive knowledge — her chapter on the Web and new media is what people need to know! She speaks with the authority of one who's been there, done that, and gone on to put it all down on paper. A true insider's view."

> — Ellen Sandler, former co-executive producer of *Everybody Loves Raymond* and author of *The TV Writer's Workbook*

"I've been writing screenplays for over 20 years. I thought I knew it all — until I read The Script-Selling Game. *The information in Kathie Fong Yoneda's fluid and fun book really enlightened me. It's an invaluable resource for any serious screenwriter."*

> — Michael Ajakwe Jr., Emmy-winning TV producer, *Talk Soup*; Executive Director of Los Angeles Web Series Festival (LAWEBFEST); and creator/writer/director of *Who... and Africabby* (AjakweTV.com)

KATHIE FONG YONEDA has worked in film and television for more than 30 years. She has held executive positions at Disney, Touchstone, Disney TV Animation, Paramount Pictures Television, and Island Pictures, specializing in development and story analysis of both live-action and animation projects. Kathie is an internationally known seminar leader on screenwriting and development and has conducted workshops in France, Germany, Austria, Spain, Ireland, Great Britain, Australia, Indonesia, Thailand, Singapore, and throughout the U.S. and Canada.

$19.95 | 248 PAGES | ORDER NUMBER 161RLS | ISBN: 9781932907919

THE HOLLYWOOD STANDARD 2ND EDITION
THE COMPLETE AND AUTHORITATIVE GUIDE TO SCRIPT FORMAT AND STYLE

CHRISTOPHER RILEY

BEST SELLER

This is the book screenwriter Antwone Fisher (*Antwone Fisher, Tales from the Script*) insists his writing students at UCLA read. This book convinced John August (*Big Fish, Charlie and the Chocolate Factory*) to stop dispensing formatting advice on his popular writing website. His new advice: Consult *The Hollywood Standard.* The book working and aspiring writers keep beside their keyboards and rely on every day. Written by a professional screenwriter whose day job was running the vaunted script shop at Warner Bros., this book is used at USC's School of Cinema, UCLA, and the acclaimed Act One Writing Program in Hollywood, and in screenwriting programs around the world. It is the definitive guide to script format.

The Hollywood Standard describes in clear, vivid prose and hundreds of examples how to format every element of a screenplay or television script. A reference for everyone who writes for the screen, from the novice to the veteran, this is the dictionary of script format, with instructions for formatting everything from the simplest master scene heading to the most complex and challenging musical underwater dream sequence. This new edition includes a quick start guide, plus new chapters on avoiding a dozen deadly formatting mistakes, clarifying the difference between a spec script and production script, and mastering the vital art of proofreading. For the first time, readers will find instructions for formatting instant messages, text messages, email exchanges and caller ID.

"Aspiring writers sometimes wonder why people don't want to read their scripts. Sometimes it's not their story. Sometimes the format distracts. To write a screenplay, you need to learn the science. And this is the best, simplest, easiest to read book to teach you that science. It's the one I recommend to my students at UCLA."

— Antwone Fisher, from the foreword

CHRISTOPHER RILEY is a professional screenwriter working in Hollywood with his wife and writing partner, Kathleen Riley. Together they wrote the 1999 theatrical feature *After the Truth*, a multiple-award-winning German language courtroom thriller.

$24.95 | 208 PAGES | ORDER NUMBER 130RLS | ISBN: 9781932907636

In a dark time. to clarity and empowerment. It took the well-guarded spread a spirit of openness and creative freedom, and ts.

The essence o have the burning desire to express themselves eir hands. We demystify the sometimes secretive wo her media crafts.

By doing so, s being positively charged, emphasizing hope and aff , and love. Grounded in the deep roots of myth, it ai ter it. It hopes to be transformative for people, oper rlds.

MWP has bu isher has so many titles on the media arts. Please discount on our books. Sign up and become part